Mystical
MOODS OF IRELAND
Book of Irish Blessings
& Proverbs

Volume V

Praise for James A. Truett's work...

"You paint as lovely a picture with your imagination as you take with your camera, James." ~ **Sue Ann Stannert Rivera**

"I am still dreaming, and praying, of being able to visit Ireland. Your pictures remind me of why I long to." ~ **Jennifer Dudley Nelson**

"Wow, stunning and beautiful as always James. Remarkable vision." ~ **Cindy Moore Mendoza**

"All the pictures you post are beautiful! You are amazing James ! Every day you put rays of sunshine in my heart ... I wish one day I'll have the chance to visit those beautiful places! Thank you very much!" ~ **Diane D. Judson**

"Your creativity brings so much joy to us all. I know one thing I'm grateful for amongst many, that's for you." ~ **Maureen Jorgensen**

Mystical
MOODS OF IRELAND
Book of Irish Blessings & Proverbs

Volume V

James A. Truett

www.JamesTruettBooks.Com

TrueStar
Publishing
UNITED STATES · IRELAND

Published by TrueStar Publishing
United States • Ireland
www.TrueStarPublishing.Com

Ordering Information:
All products in the Moods of Ireland series including books, calendars, posters, cards and prints are available at special quantity discounts for bulk purchases for sales promotions, premiums, fund raising, educational, corporate or institutional use. Specially customized books, calendars, posters, cards and prints can also be created to fit specific needs. For details, please e-mail the publisher at: specialsales@truestarpublishing.com

ISBN: 978-1-948522-04-5

First Edition: November 2015

10 9 8 7 6 5 4 3 2 1

COVER: *A Celtic Cross marks a grave at Dysert O'Dea Cemetery near the village of Corofin in County Clare.*

Dedication

For my Irish family,
Francis & Helen Murphy

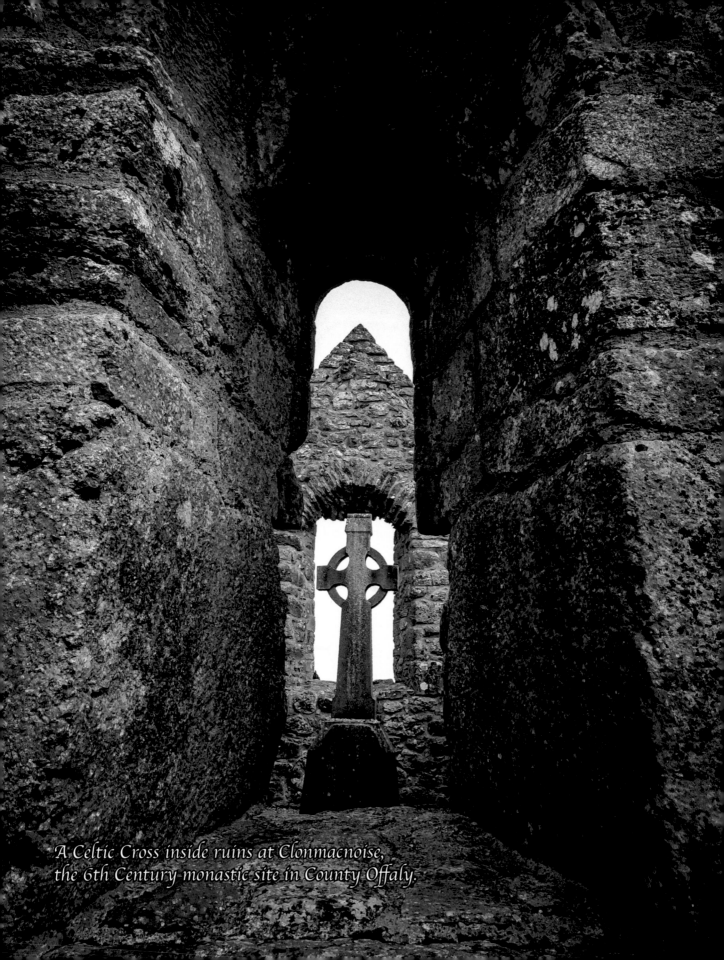

A Celtic Cross inside ruins at Clonmacnoise,
the 6th Century monastic site in County Offaly.

Introduction

Book of Irish Blessings & Proverbs

Throughout history, the Irish people have endured great hardship, from Viking invasions and political wars to the Great Famine, but their spirit has survived and thrived with a resilience embodied by a deep and soulful wisdom.

While the small island is home to about 6.6 million residents as of 2015 (4.8 million in the Republic of Ireland, and 1.8 million in Northern Ireland), an estimated 70 million people around the world share Irish ancestry.

Since 1700, nearly 10 million people born in Ireland have left the shores of the Emerald Isle for economically greener pastures elsewhere. They carried with them not only their dreams for better lives, but also the timeless wisdom and kind wishes of Irish blessings and proverbs.

This book pairs this warm, wise and welcoming spirit with the incredible natural beauty of Ireland through these time-honored and life-proven verses accompanied by images of the magical Irish countryside.

As you read and view the images, imagine yourself in a cozy, thatched cottage in the Irish countryside, warming your feet in front of a roaring turf fire, and above all, remember our ancestors.

They survived those challenging times to make a better world for us all.

With eternal gratitude,

James A. Truett
County Clare, Ireland

Bless you and yours

As well as the cottage you live in.

May the roof overhead be well thatched

And those inside be well matched.

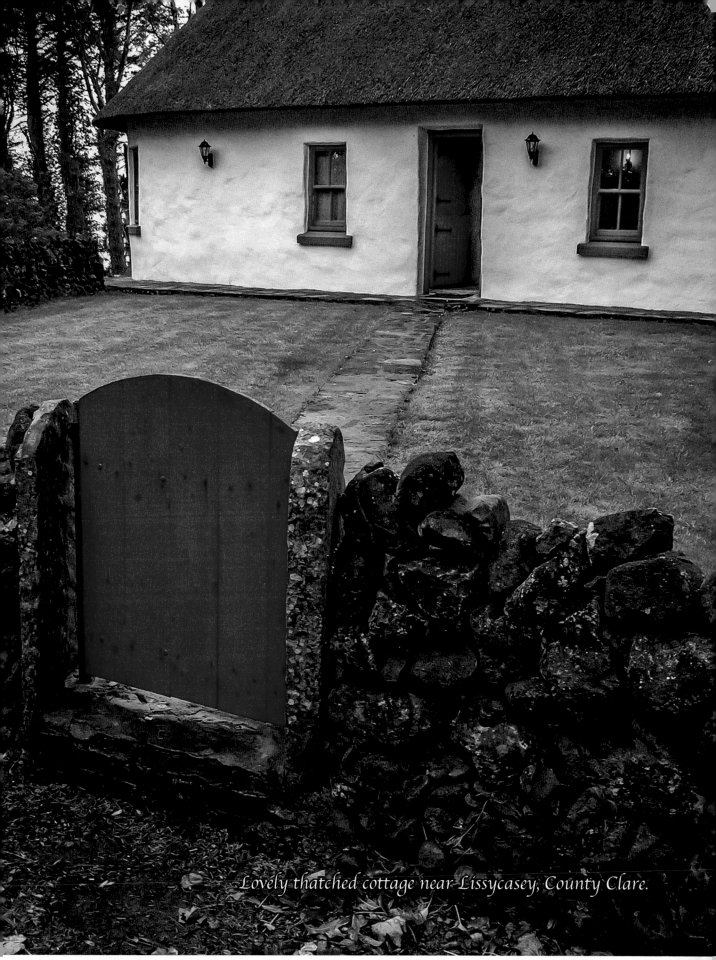

Lovely thatched cottage near Lissycasey, County Clare.

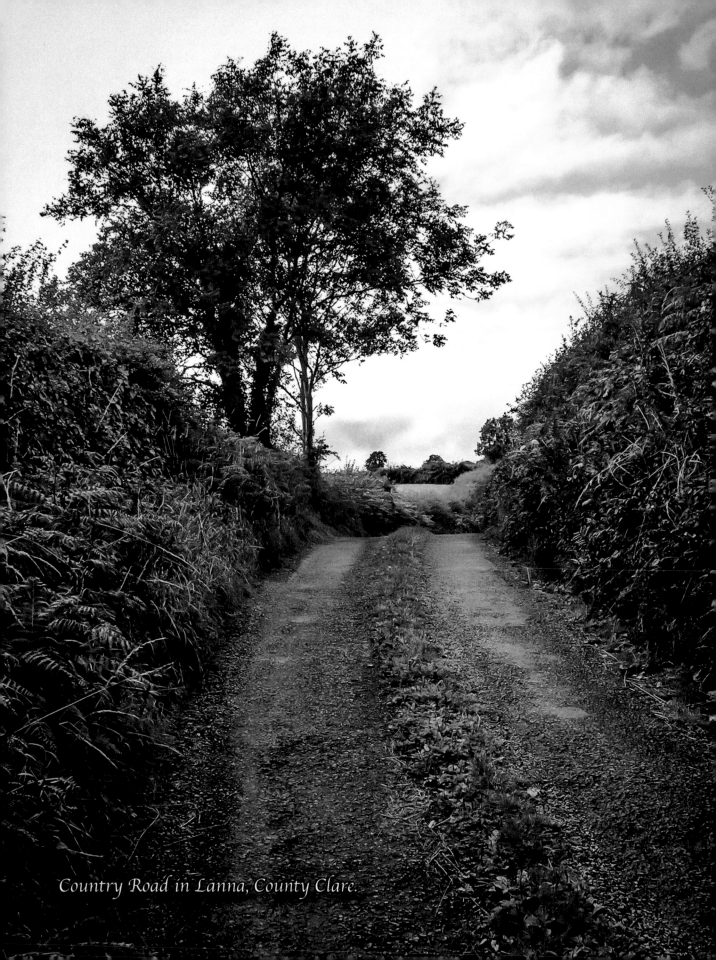

Country Road in Lanna, County Clare.

May the road rise up to meet you.

May the wind always be at your back.

May the sun shine warm upon your face,

and rains fall soft upon your fields.

And until we meet again,

May God hold you in the palm of His

hand.

May your hearth be warm

Your holidays grand

And your heart held gently

In the good Lord's hand.

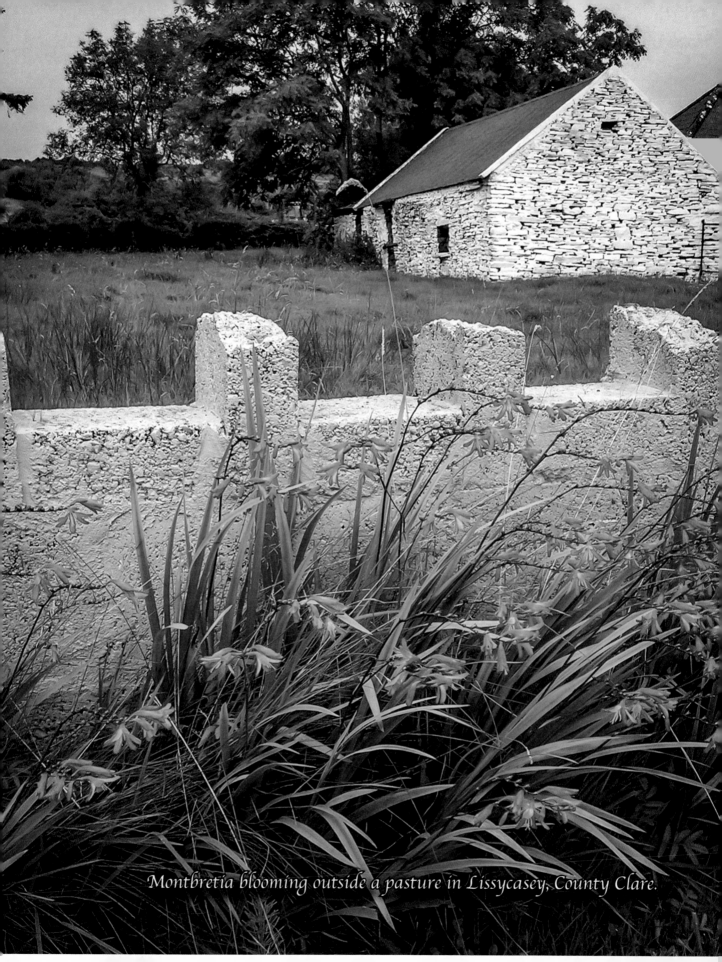

Montbretia blooming outside a pasture in Lissycasey, County Clare.

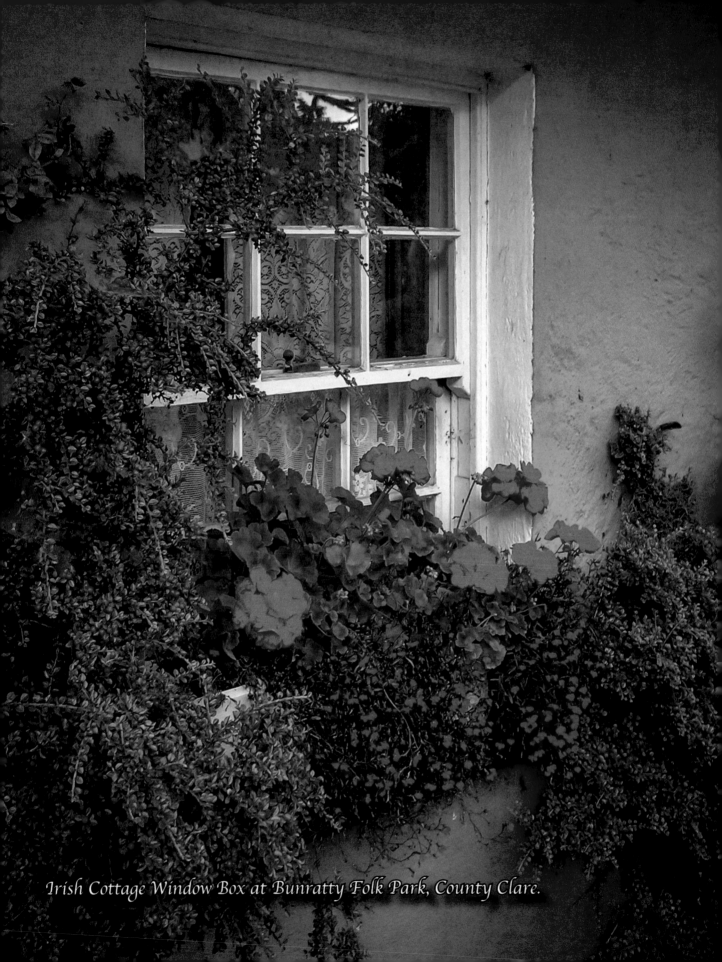

Irish Cottage Window Box at Bunratty Folk Park, County Clare.

May love and laughter light your days,

and warm your heart and home.

May good and faithful friends be yours,

wherever you may roam.

May peace and plenty bless your world

with joy that long endures.

May all life's passing seasons

bring the best to you and yours!

May the luck of the Irish

Lead to happiest heights

And the highway you travel

Be lined with green lights.

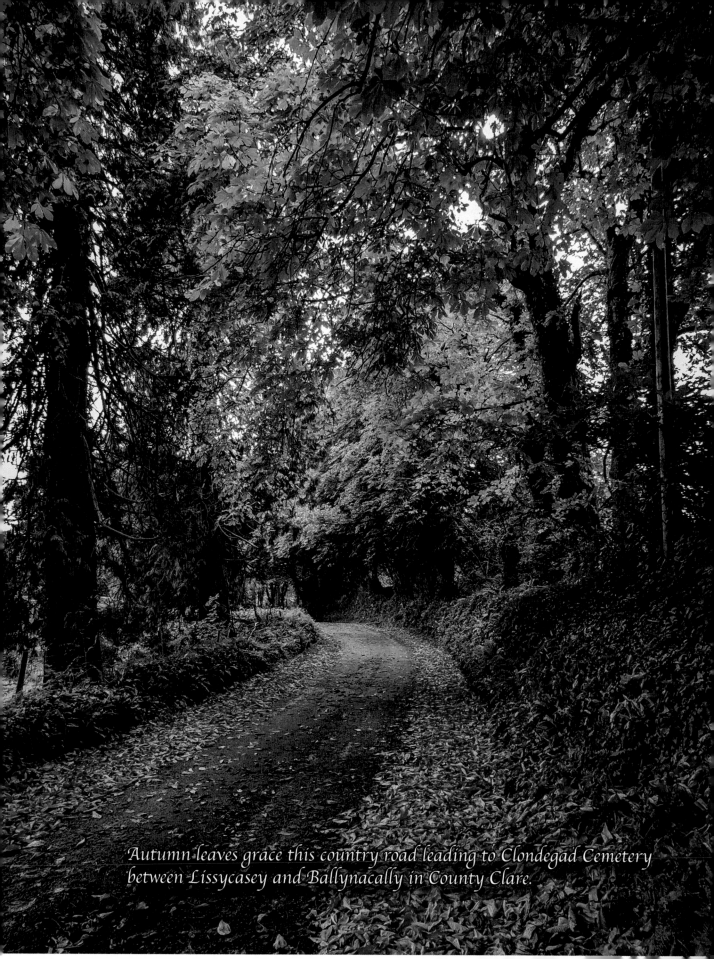

Autumn leaves grace this country road leading to Clondegad Cemetery between Lissycasey and Ballynacally in County Clare.

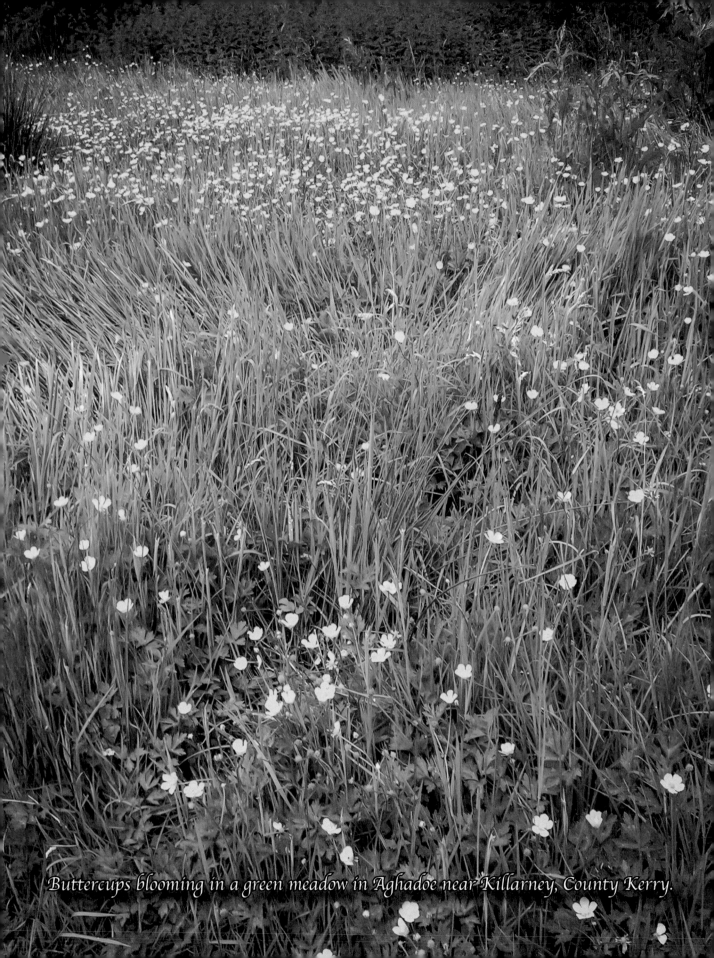

Buttercups blooming in a green meadow in Aghadoe near Killarney, County Kerry.

Dance as though no one is watching you,

Love as though you have never loved before,

Sing as though no one can hear you,

Live as though heaven is on earth.

May you have the hindsight

To know where you've been,

The foresight to know where you're going,

And the insight to know

When you're going too far.

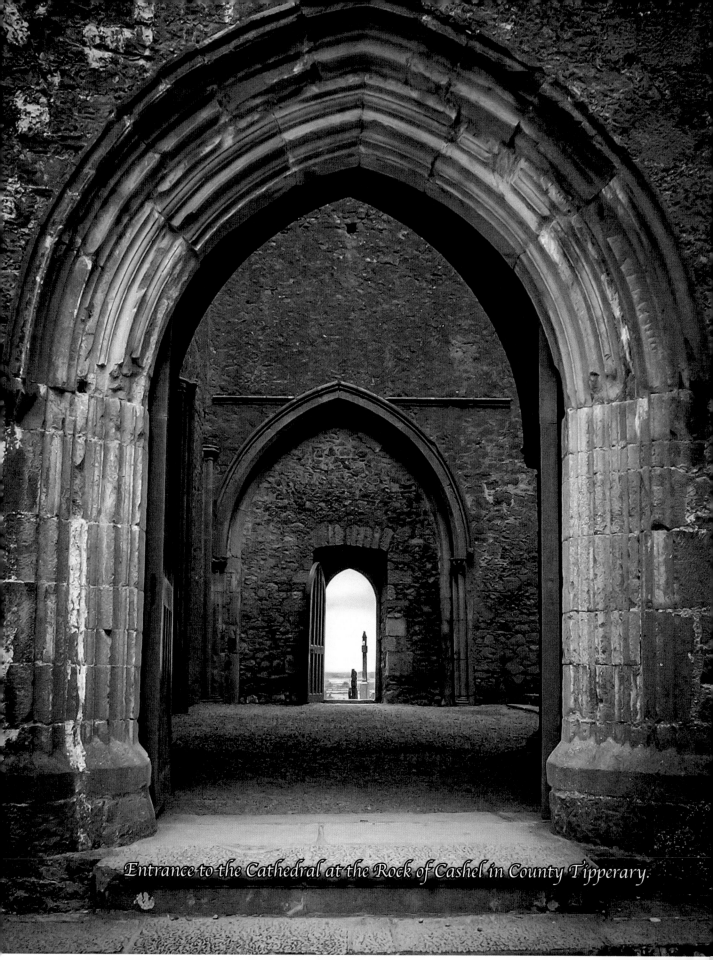

Entrance to the Cathedral at the Rock of Cashel in County Tipperary.

May the good saints protect you,

And bless you today.

And may troubles ignore you,

Each step of the way.

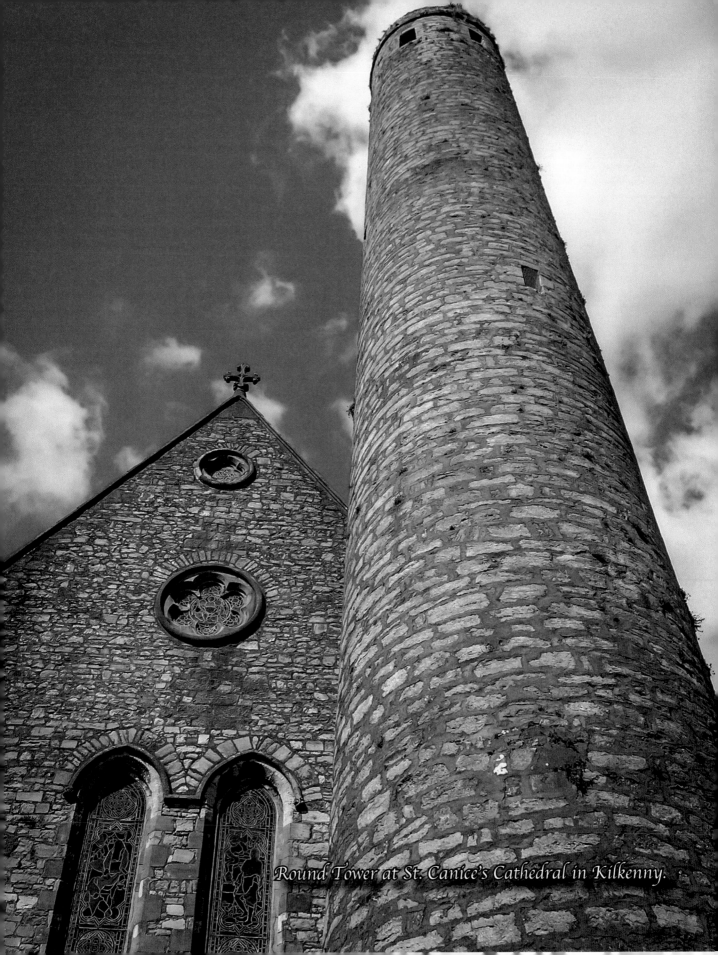

Round Tower at St. Canice's Cathedral in Kilkenny.

May your troubles be less

And your blessings be more.

And nothing but happiness

Come through your door.

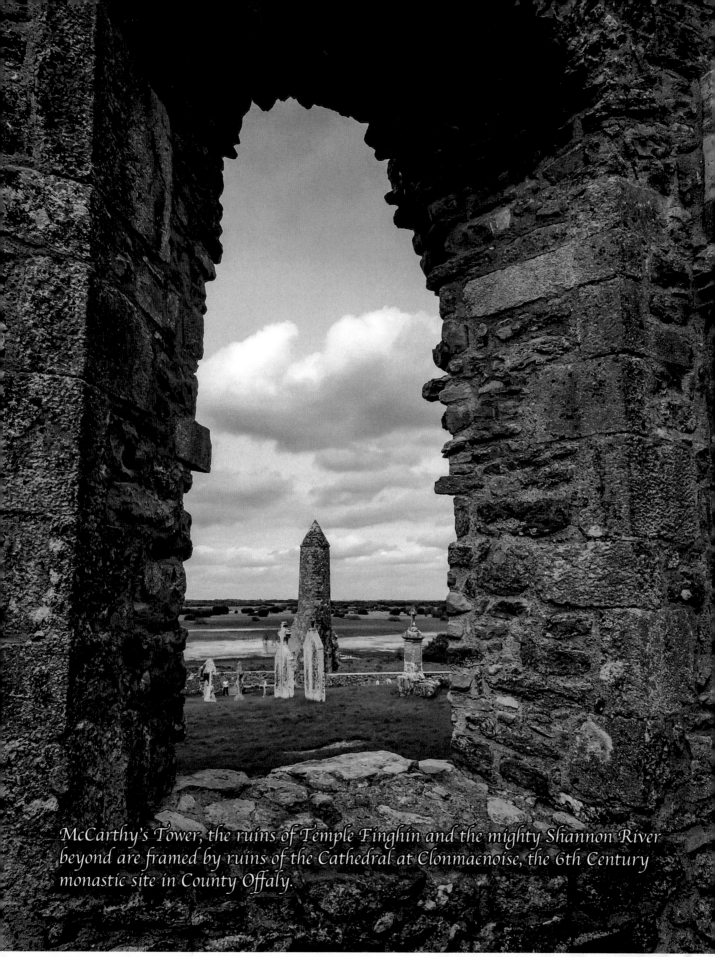

McCarthy's Tower, the ruins of Temple Finghin and the mighty Shannon River beyond are framed by ruins of the Cathedral at Clonmacnoise, the 6th Century monastic site in County Offaly.

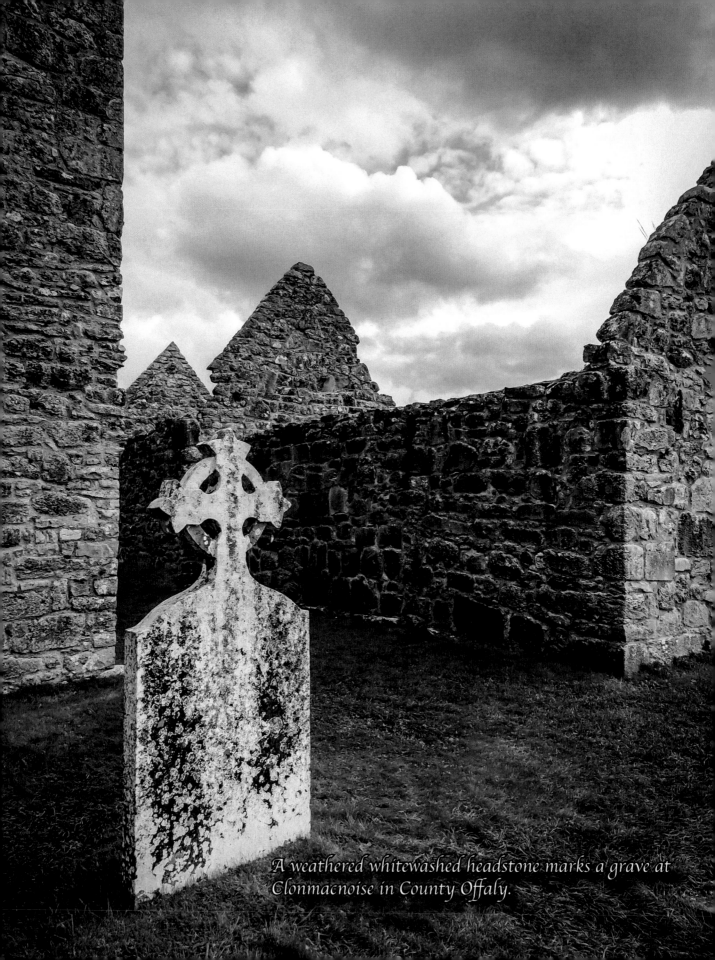

A weathered whitewashed headstone marks a grave at Clonmacnoise in County Offaly.

May your thoughts be

As glad as the shamrocks.

May your heart be

As light as a song.

May each day bring you

Bright happy hours,

That stay with you all year long.

May you be blessed with

Warmth in your home,

Love in your heart,

Peace in your soul

And joy in your life.

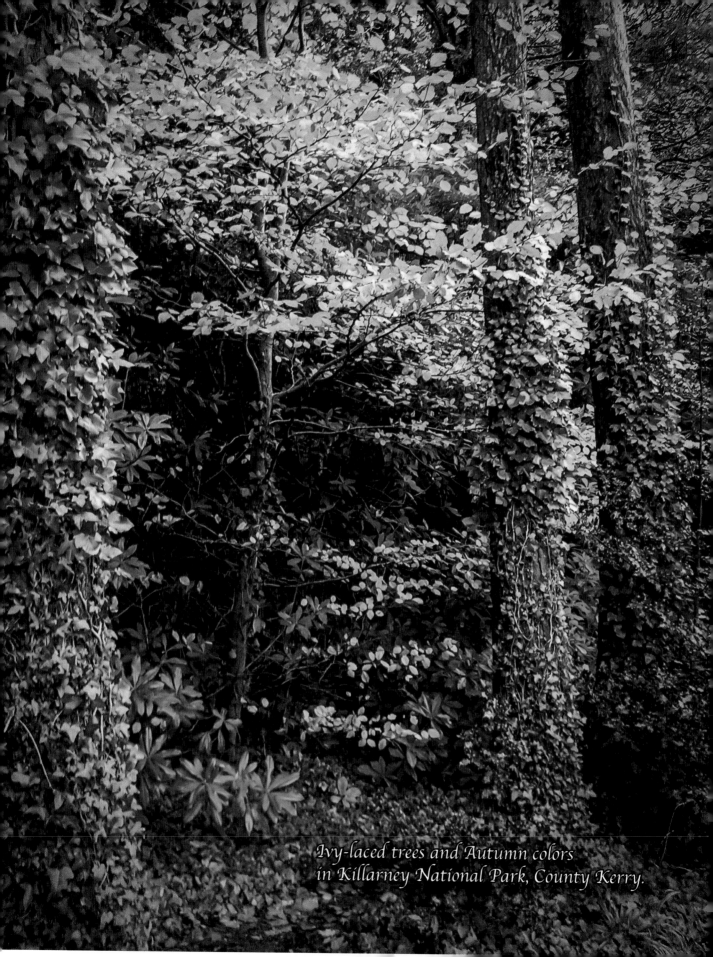

Ivy-laced trees and Autumn colors
in Killarney National Park, County Kerry.

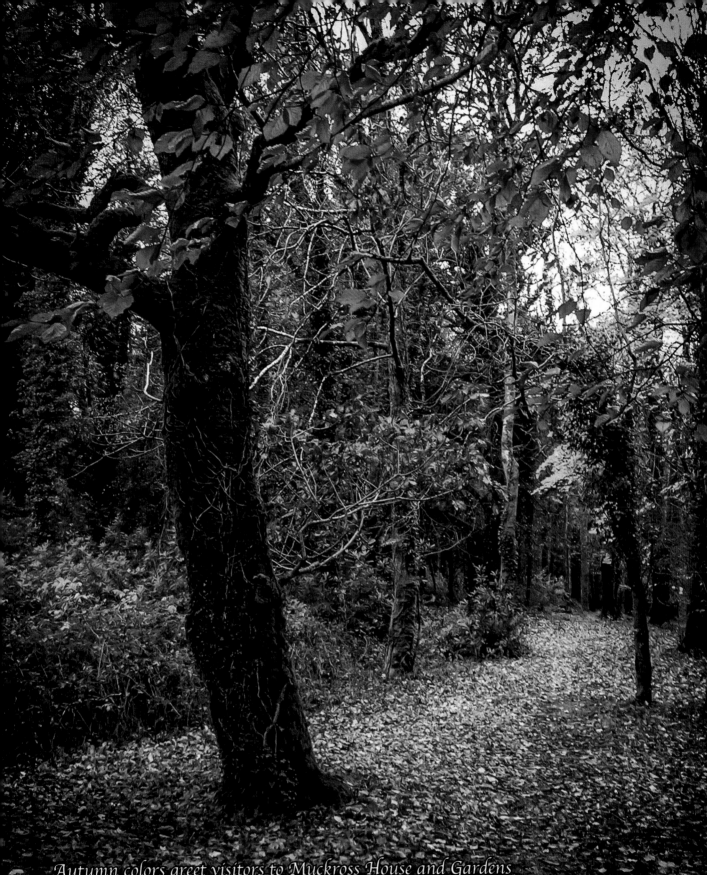

Autumn colors greet visitors to Muckross House and Gardens
in Killarney, County Kerry.

May your pockets be heavy

And your heart be light.

May good luck pursue you

Each morning and night.

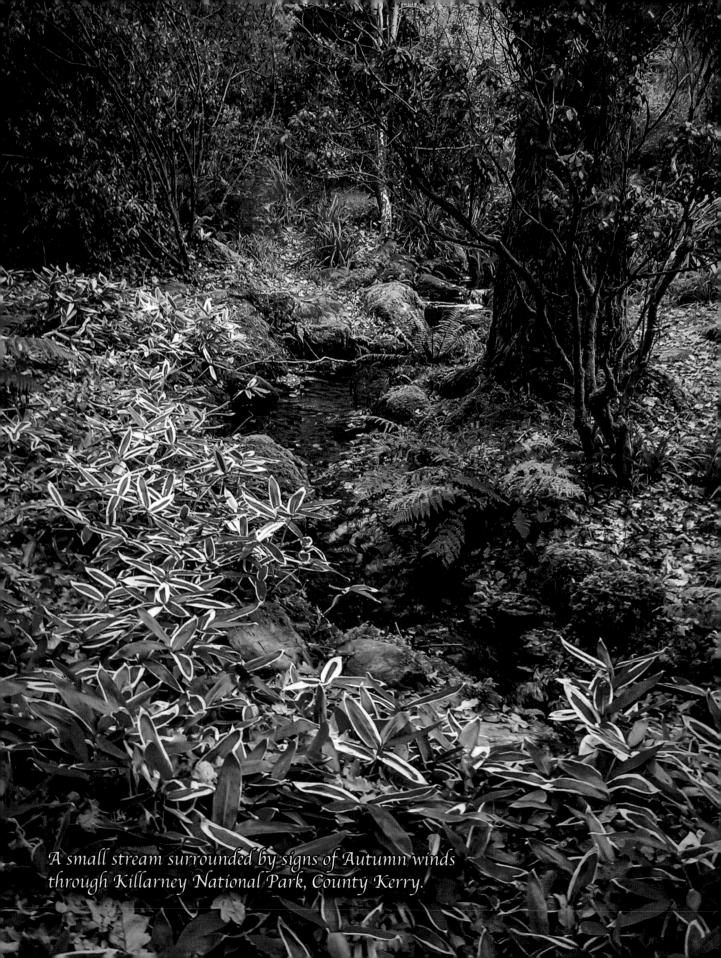

A small stream surrounded by signs of Autumn winds
through Killarney National Park, County Kerry.

For each petal on the shamrock

This brings a wish your way,

Good health, good luck, and happiness

For today and every day.

May you have warm words

On a cold evening,

A full moon on a dark night,

And the road downhill

All the way to your door.

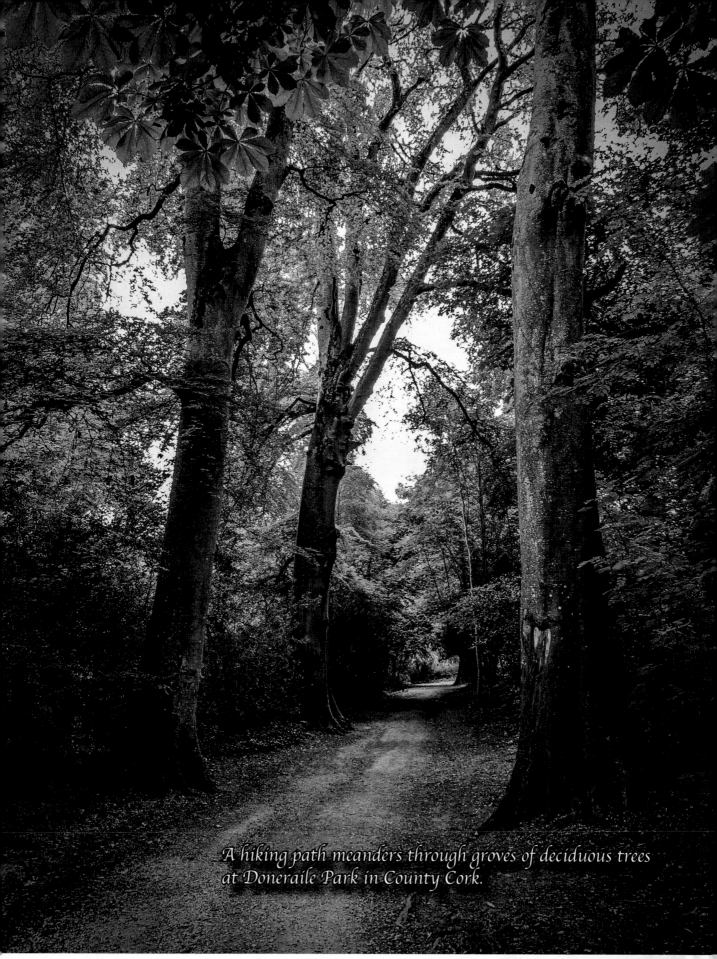

A hiking path meanders through groves of deciduous trees
at Doneraile Park in County Cork.

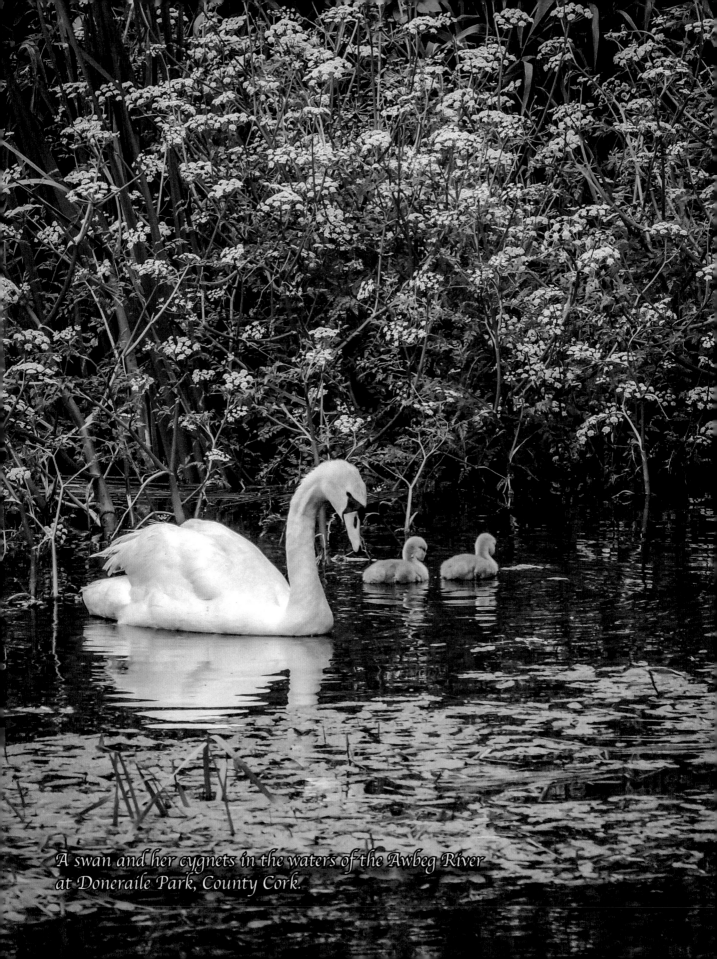

A swan and her cygnets in the waters of the Awbeg River at Doneraile Park, County Cork.

May brooks and trees and singing hills

Join in the chorus, too.

And every gentle wind that blows

Send happiness to you.

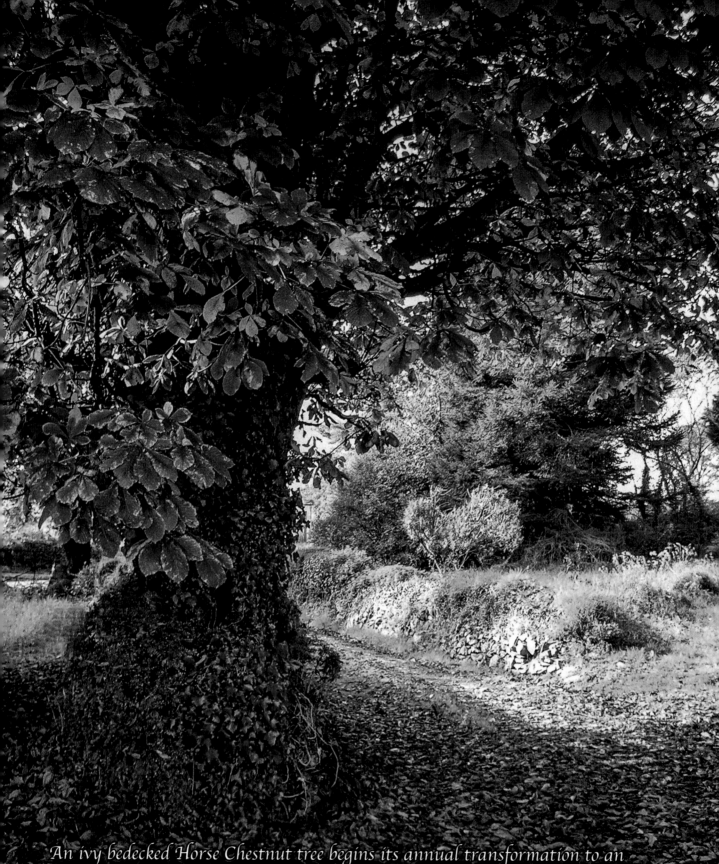

An ivy bedecked Horse Chestnut tree begins its annual transformation to an Autumn wardrobe on the former Cullinan Farm in Lanna, County Clare.

May your blessings outnumber

The shamrocks that grow,

And may trouble avoid you

Wherever you go.

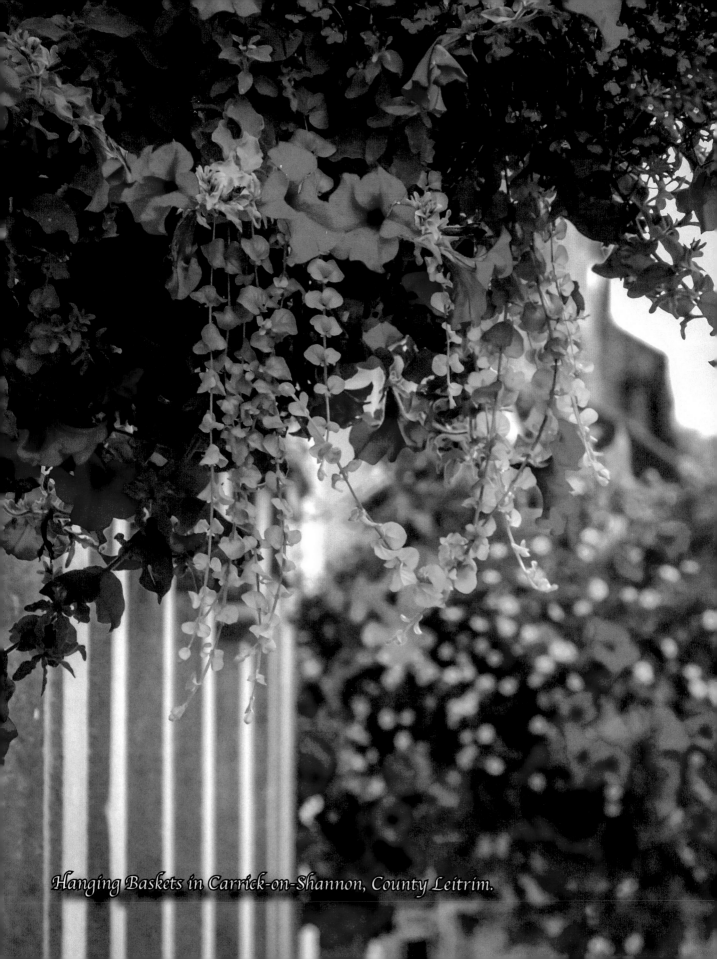

Hanging Baskets in Carrick-on-Shannon, County Leitrim.

May there always be work for your hands to do,

May your purse always hold a coin or two.

May the sun always shine warm

on your window pane,

May a rainbow be certain to follow each rain.

May the hand of a friend always be near you,

And may God fill your heart

with gladness to cheer you.

May your day be filled with blessings
Like the sun that lights the sky,
And may you always have the courage
To spread your wings and fly.

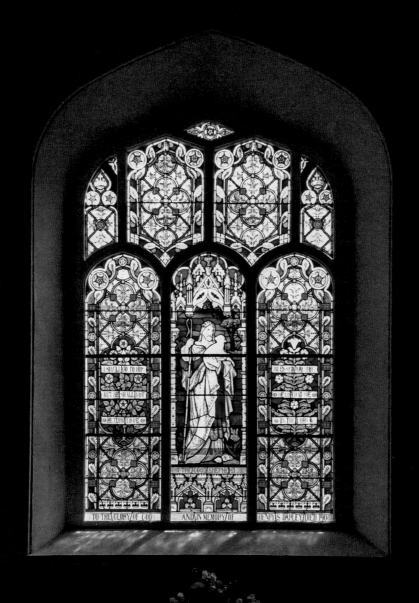

Stained glass inside St. George's Church at Carrick-on-Shannon in County Leitrim.

Brightly colored purple flowers accent a hedgerow
in the County Clare countryside.

Like the warmth of the sun

And the light of the day,

May the luck of the Irish

shine bright on your way.

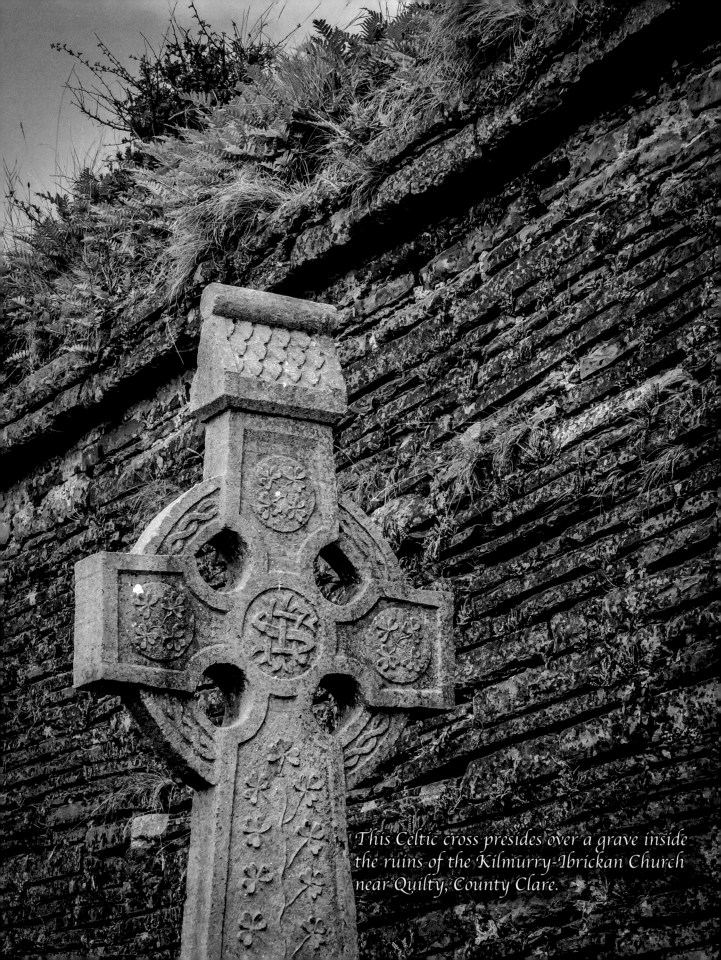

This Celtic cross presides over a grave inside the ruins of the Kilmurry-Ibrickan Church near Quilty, County Clare.

May your neighbors respect you,

Trouble neglect you,

The angels protect you,

And heaven accept you.

A cabin with plenty of food

Is better than a hungry castle.

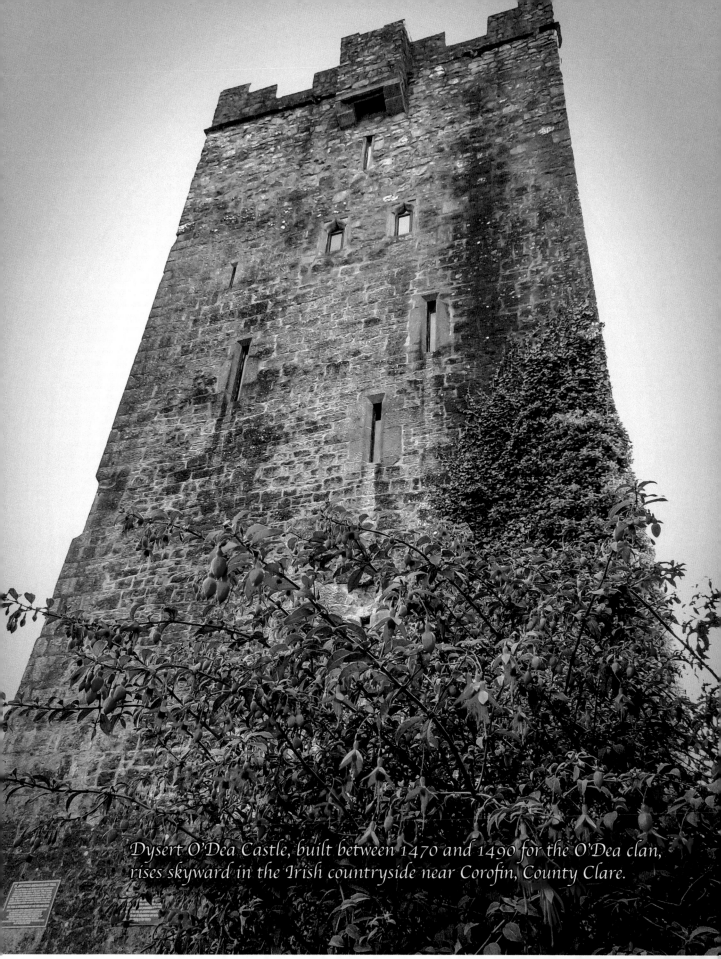

Dysert O'Dea Castle, built between 1470 and 1490 for the O'Dea clan, rises skyward in the Irish countryside near Corofin, County Clare.

May you always have

Walls for the winds,

A roof for the rain,

Tea beside the fire,

Laughter to cheer you,

Those you love near you,

And all your heart might desire.

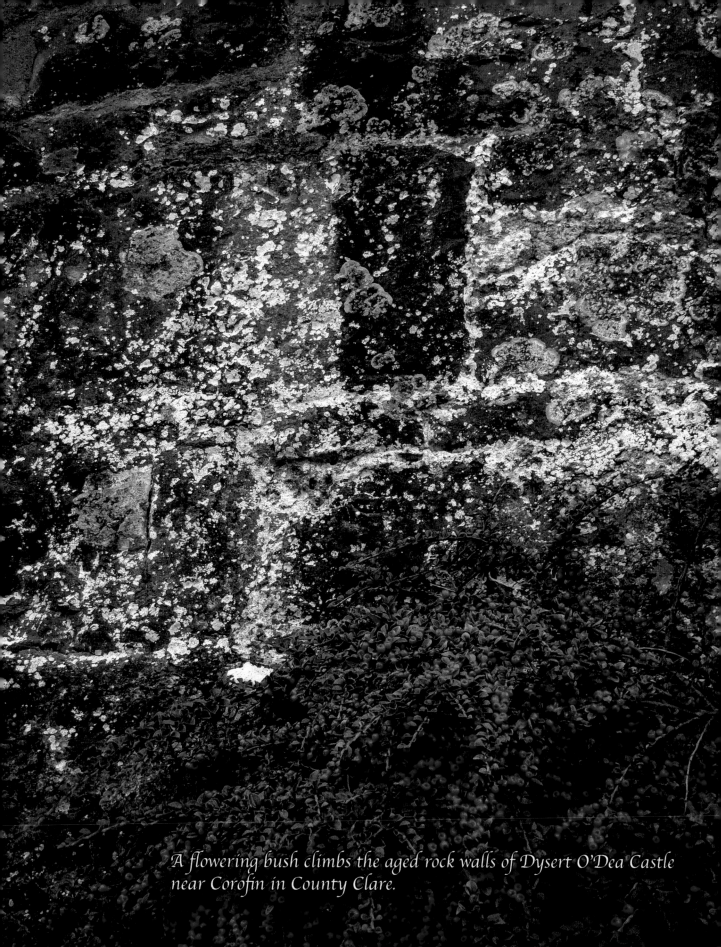

A flowering bush climbs the aged rock walls of Dysert O'Dea Castle near Corofin in County Clare.

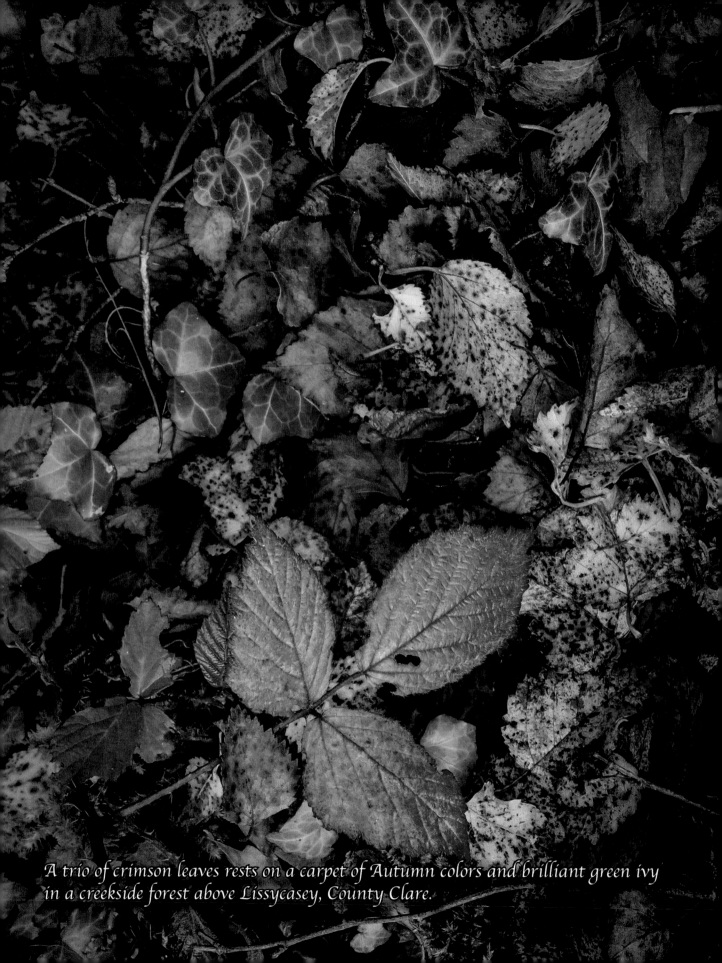

A trio of crimson leaves rests on a carpet of Autumn colors and brilliant green ivy
in a creekside forest above Lissycasey, County Clare.

Wherever you go, and

Whatever you do,

May the luck of the Irish

Be there with you.

Wishing you a rainbow

For sunlight after showers,

Miles and miles of Irish smiles

For golden happy hours,

Shamrocks at your doorway

For luck and laughter too,

And a host of friends that never ends

Each day your whole life through!

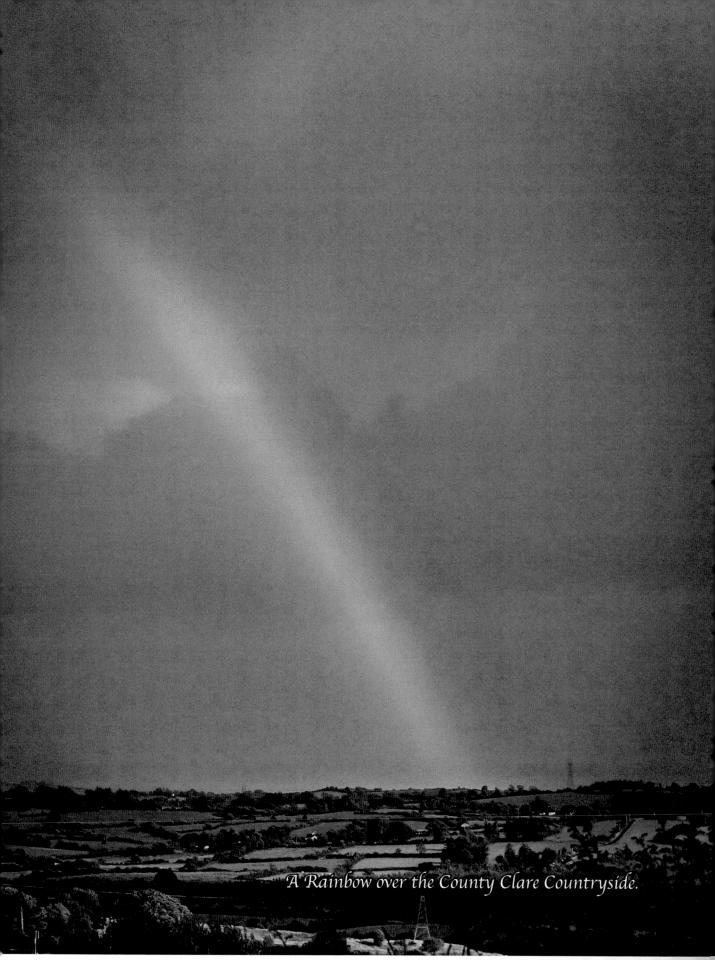

A Rainbow over the County Clare Countryside.

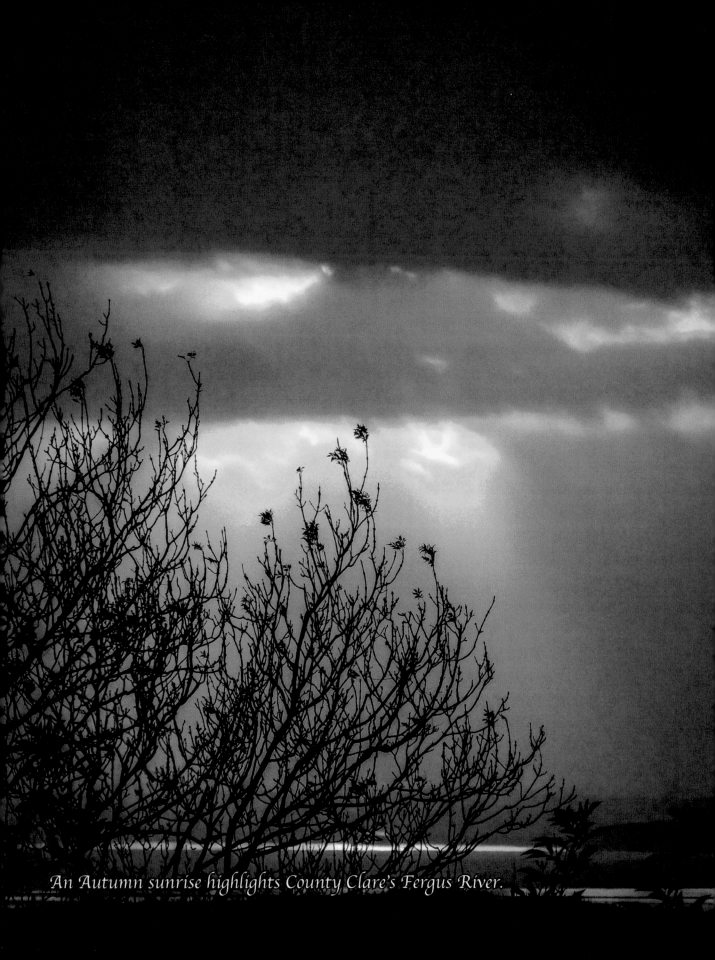

An Autumn sunrise highlights County Clare's Fergus River.

May dawn find you awake and alert,

Approaching your new day with

Dreams, possibilities, and promises.

May evening find you gracious and fulfilled.

May you go into the night

Blessed, sheltered, and protected.

May your soul calm, console, and renew you.

A sunbeam to warm you,

Good luck to charm you.

A Sheltering angel,

So nothing can harm you,

Laughter to cheer you,

Faithful friends near you,

And whenever you pray,

Heaven to hear you.

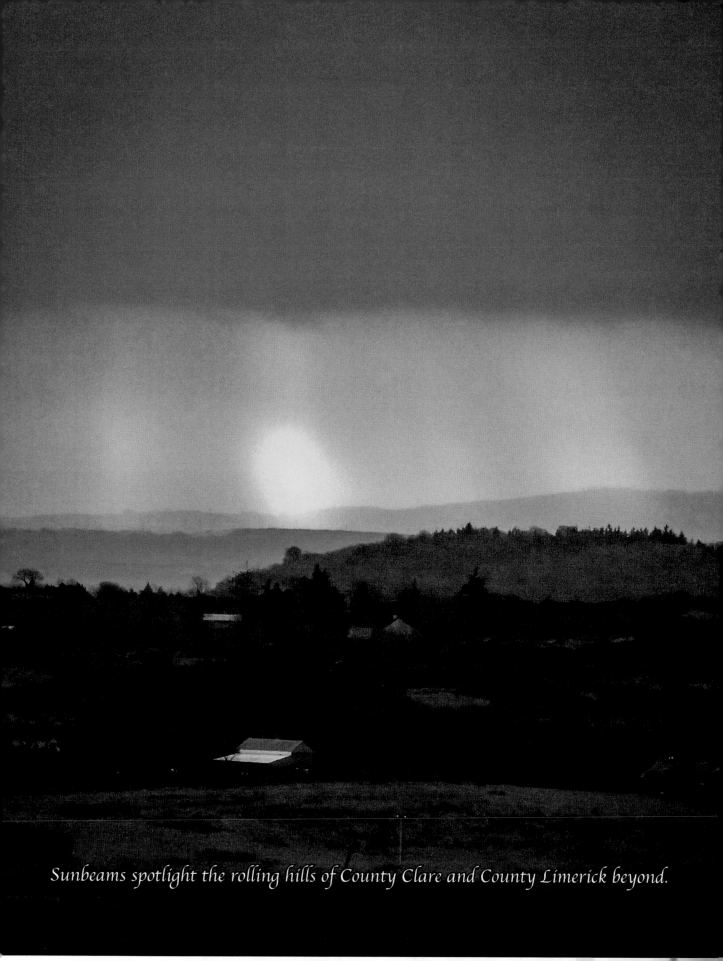

Sunbeams spotlight the rolling hills of County Clare and County Limerick beyond.

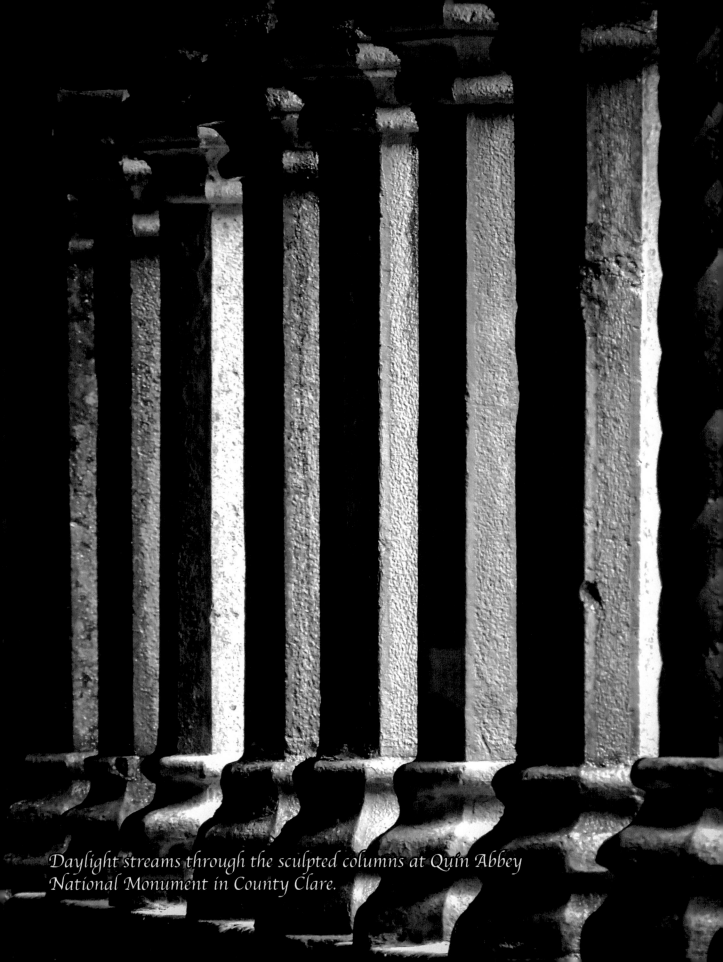

Daylight streams through the sculpted columns at Quin Abbey
National Monument in County Clare.

A world of wishes at your command,

God and his angels close at hand,

Friends and family, their love impart,

And Irish blessings in your heart.

May the Good Lord

Take a liking to you,

... but not too soon!

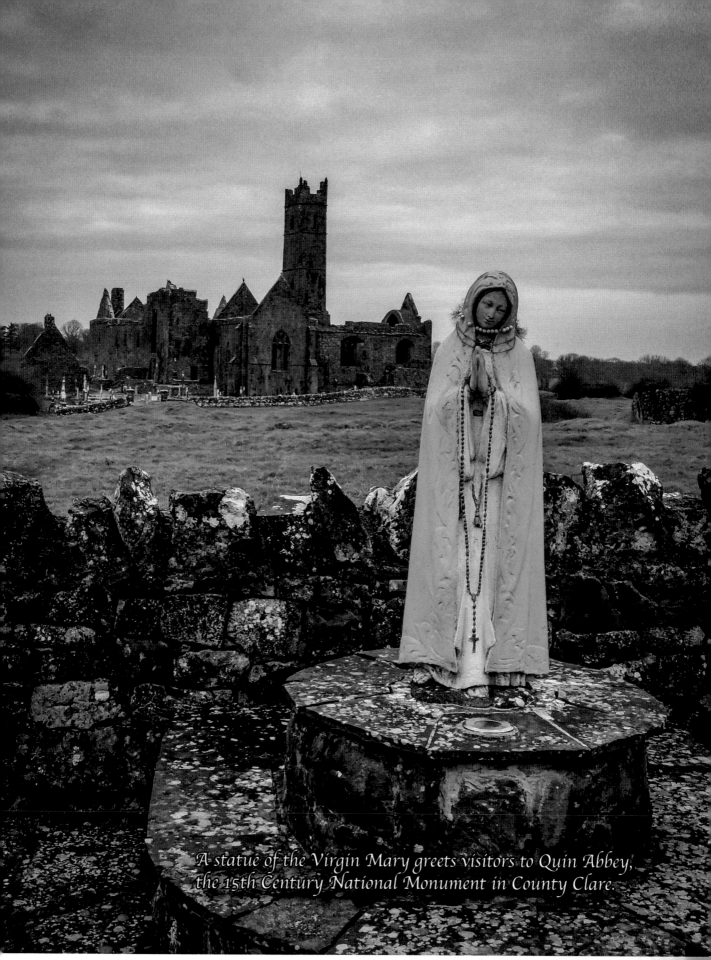

A statue of the Virgin Mary greets visitors to Quin Abbey, the 15th Century National Monument in County Clare.

May you always walk in sunshine.

May you never want for more.

May Irish angels rest their wings

Right beside your door.

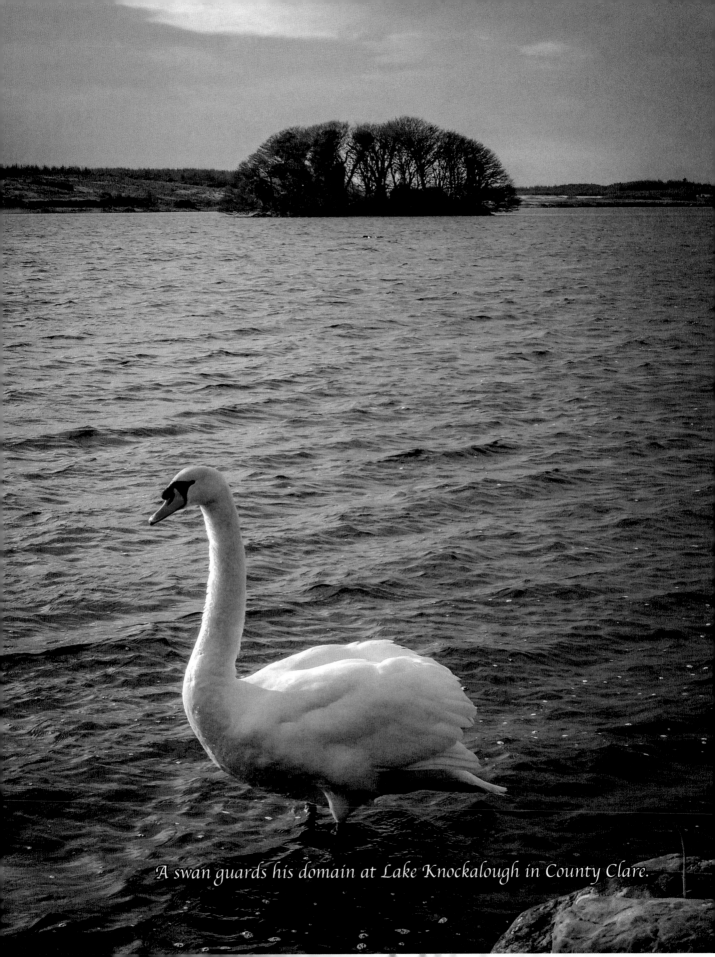

A swan guards his domain at Lake Knockalough in County Clare.

We're on this Earth together,

And if we would be brothers,

Fight not just on your own behalf

But for the sake of others.

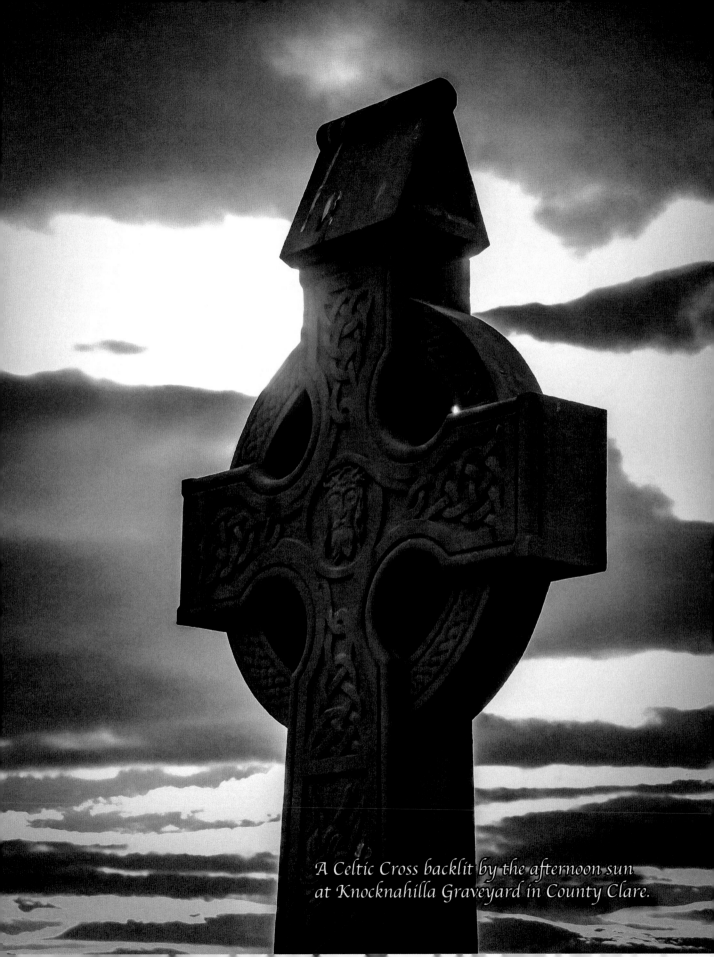

A Celtic Cross backlit by the afternoon sun at Knocknahilla Graveyard in County Clare.

May your right hand always

Be stretched out in friendship

And never in want.

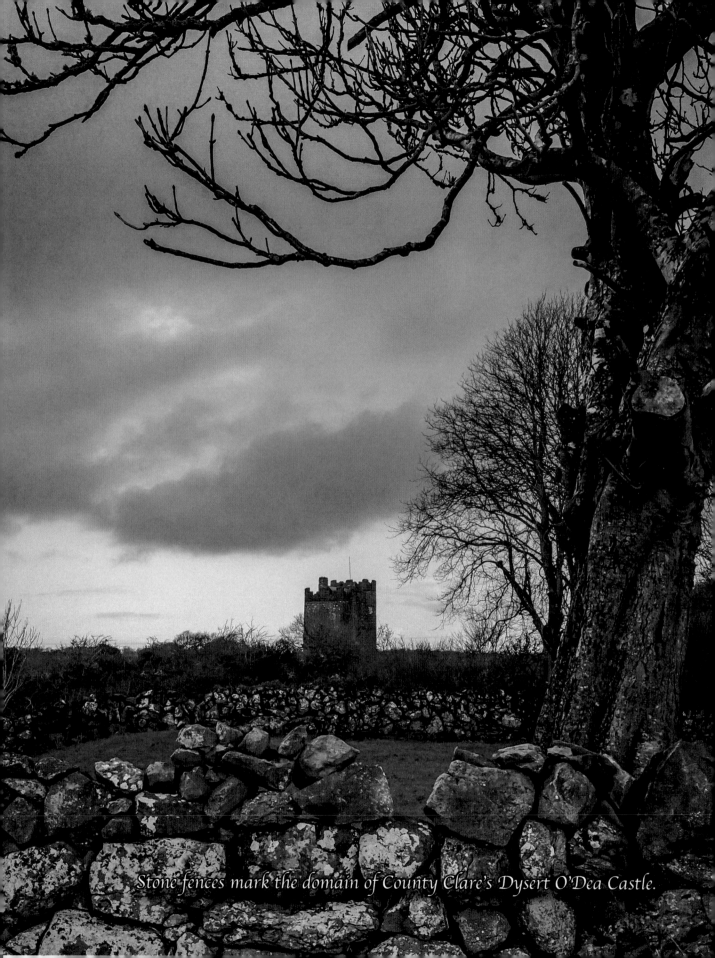

Stone fences mark the domain of County Clare's Dysert O'Dea Castle.

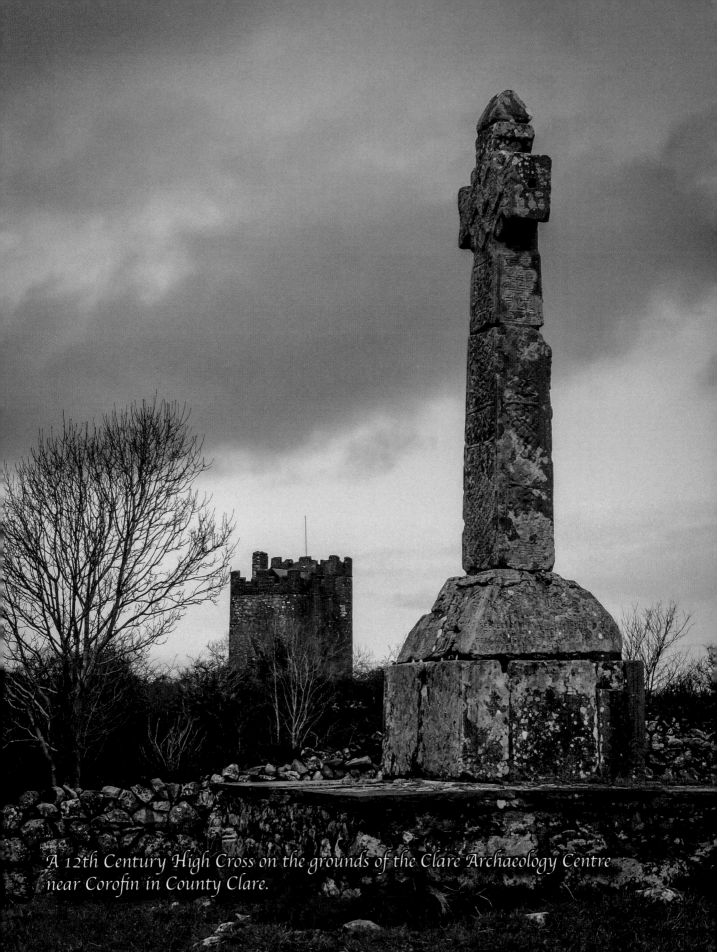

A 12th Century High Cross on the grounds of the Clare Archaeology Centre near Corofin in County Clare.

May luck be our companion,

May friends stand by our side,

May history remind us all

Of Ireland's faith and pride.

May the sound of happy music

And the lilt of Irish laughter

Fill your heart with gladness

That stays forever after.

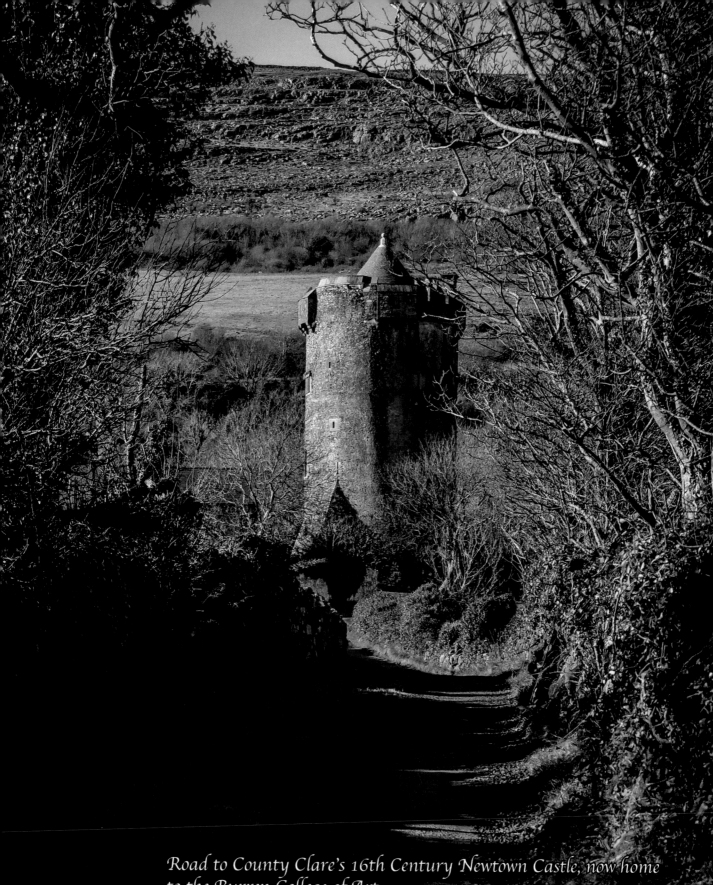

Road to County Clare's 16th Century Newtown Castle, now home to the Burren College of Art.

May the nourishment of the earth be yours,

May the clarity of light be yours,

May the fluency of the ocean be yours,

May the protection of the ancestors be yours.

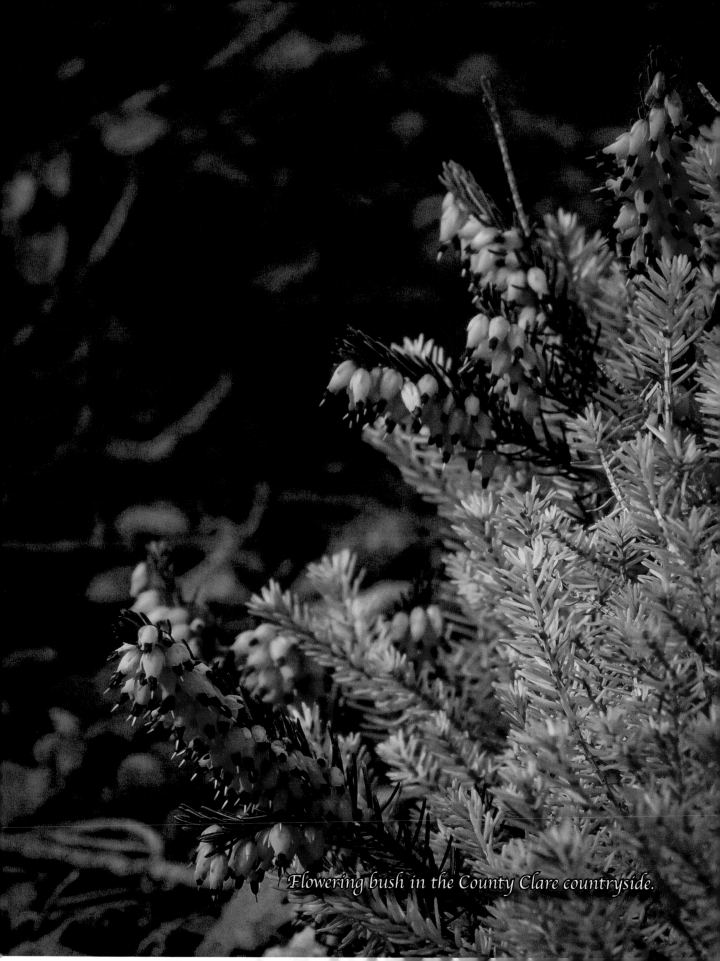

Flowering bush in the County Clare countryside.

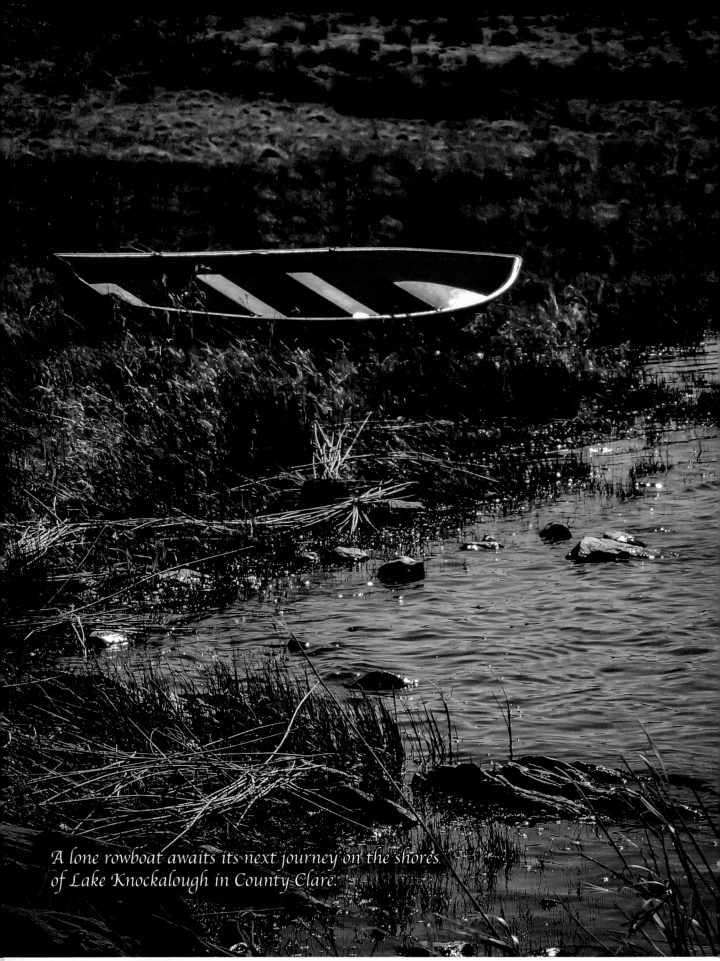

A lone rowboat awaits its next journey on the shores
of Lake Knockalough in County Clare.

There are good ships,

And there are wood ships,

The ships that sail the sea,

But the best ships are friendships,

And may they always be.

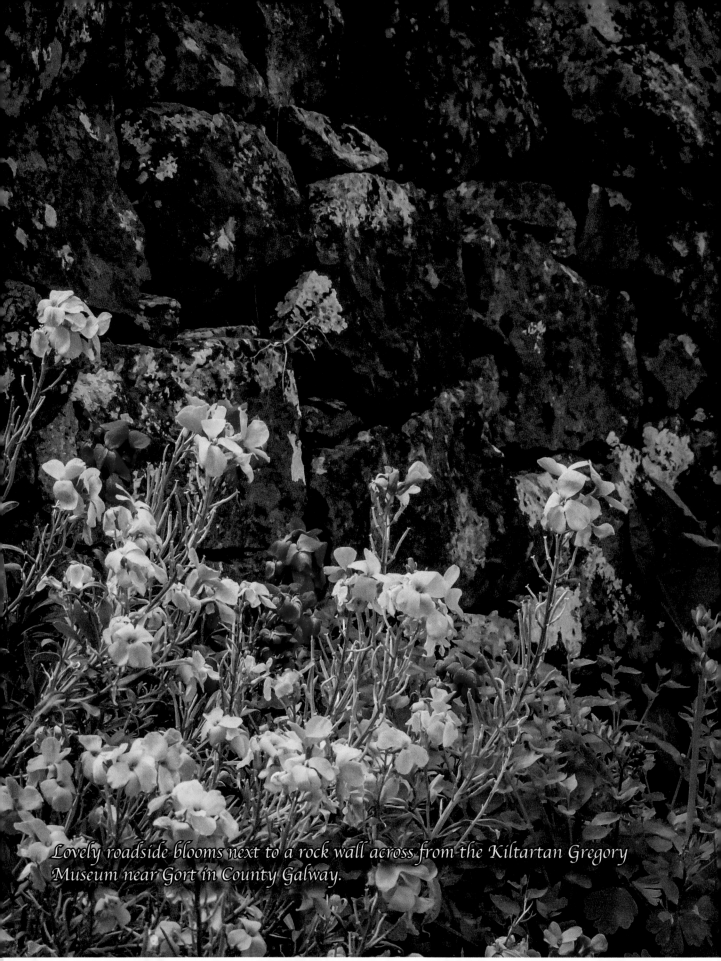

Lovely roadside blooms next to a rock wall across from the Kiltartan Gregory Museum near Gort in County Galway.

May the sun shine all day long,

Everything go right

And nothing go wrong.

May those you love

Bring love back to you

And may all the wishes

You wish come true!

May the sun shine bright

On your joyous days,

And the rain refresh you

Through peaceful nights.

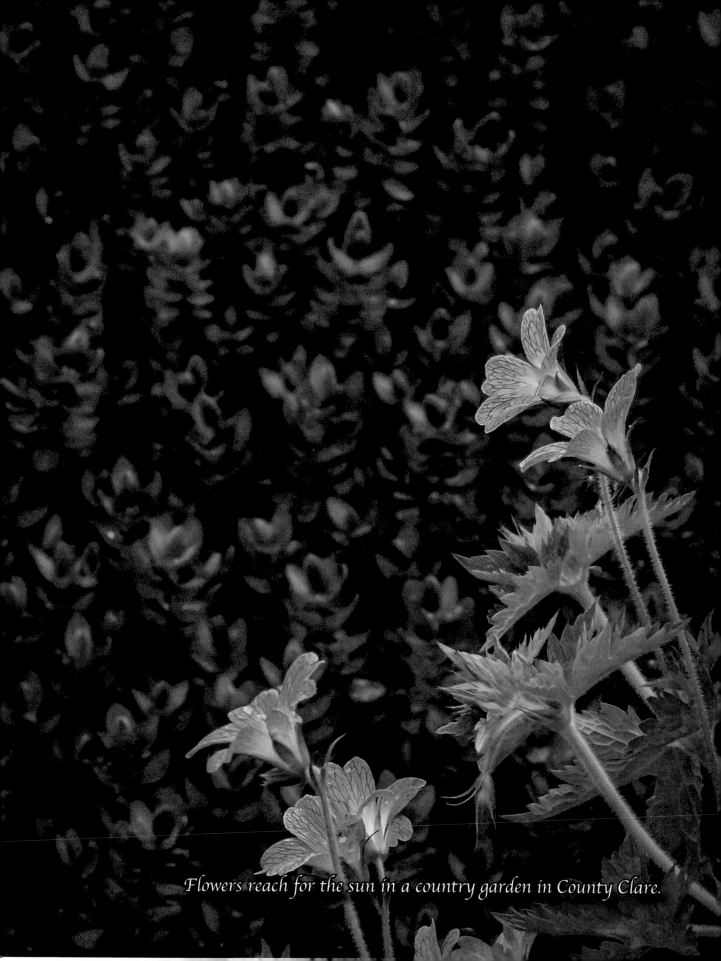

Flowers reach for the sun in a country garden in County Clare.

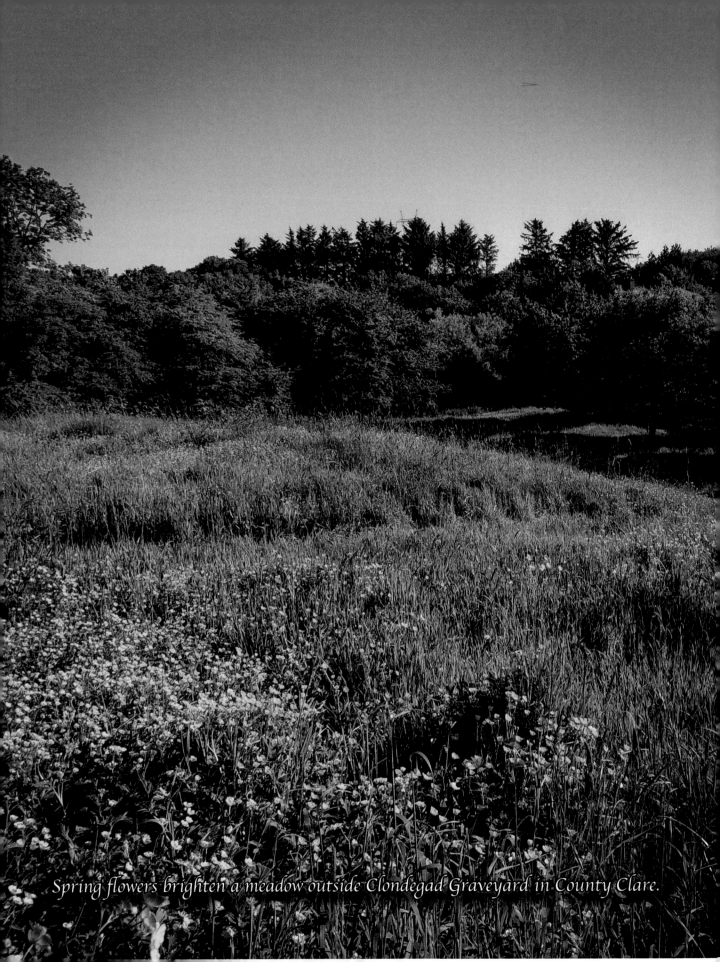

Spring flowers brighten a meadow outside Clondegad Graveyard in County Clare.

May green be the grass you walk on.

May blue be the skies above you.

May pure be the joys that surround you.

May true be the hearts that love you.

May you have love that never ends,

Lots of money, and lots of friends,

Health be yours, whatever you do,

And may God send many blessings to you.

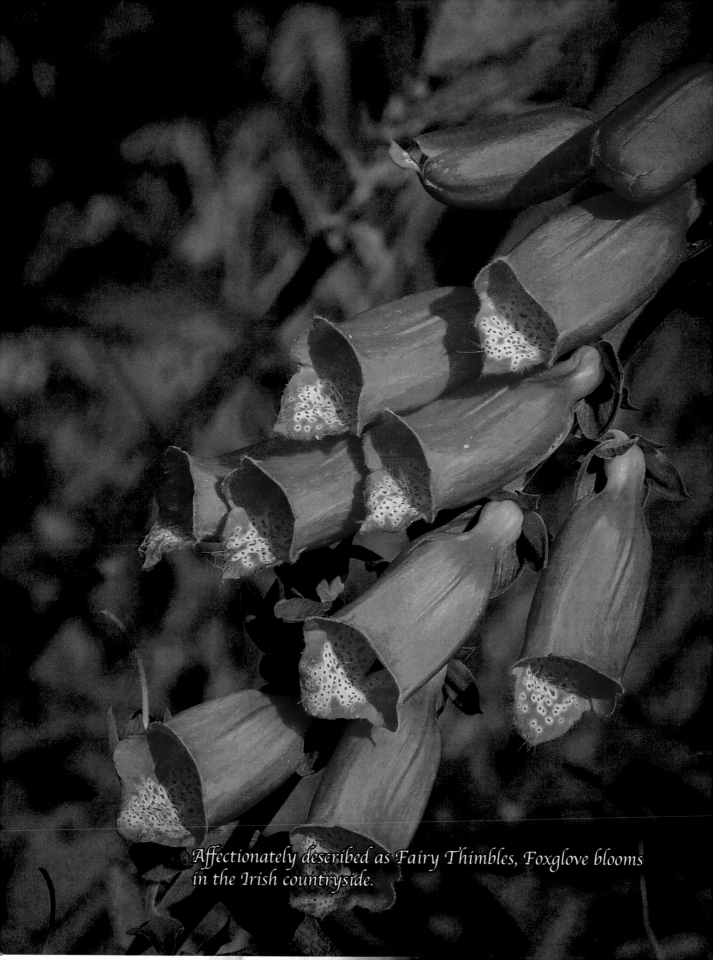

Affectionately described as Fairy Thimbles, Foxglove blooms in the Irish countryside.

May the blessings of light be upon you,

Light without and light within,

And in all your comings and goings,

May you ever have a kindly greeting

From them you meet along the road.

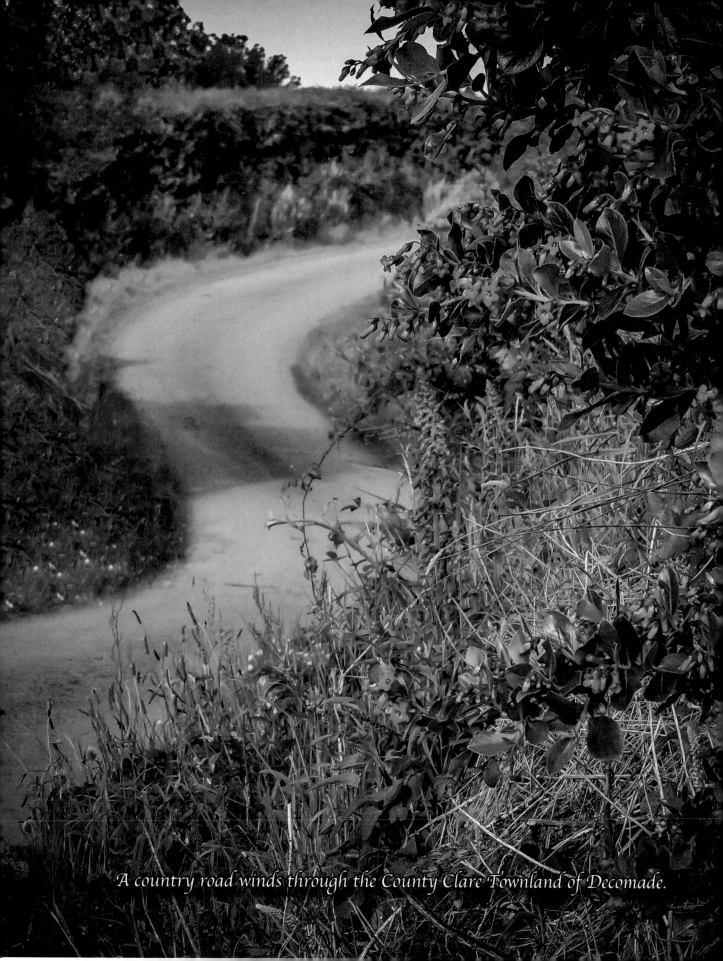

A country road winds through the County Clare Townland of Decomade.

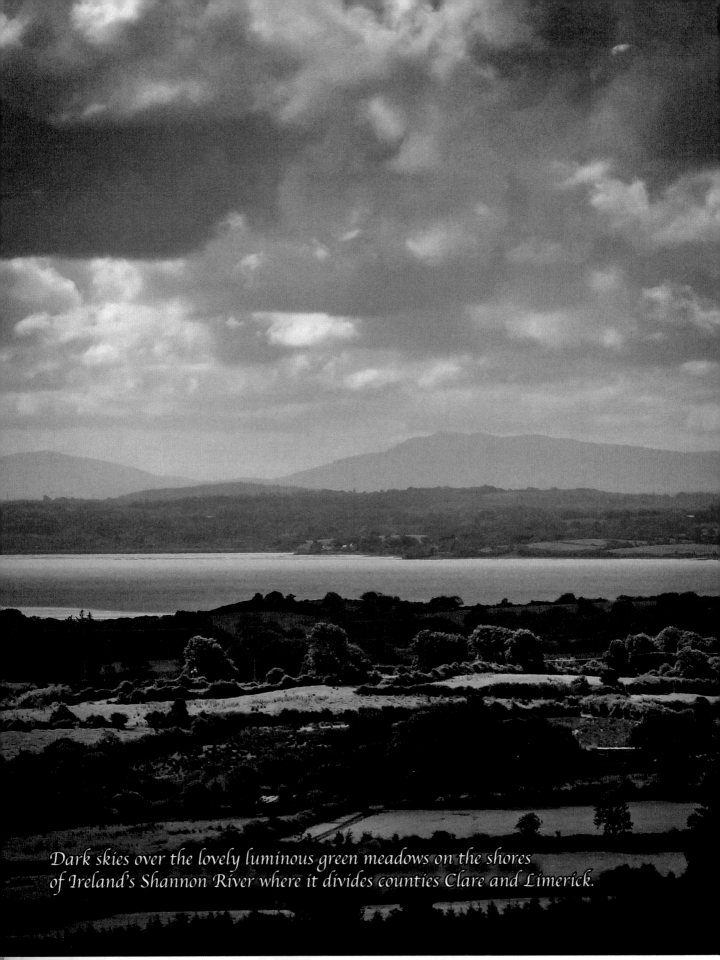

Dark skies over the lovely luminous green meadows on the shores
of Ireland's Shannon River where it divides counties Clare and Limerick.

May the Irish hills caress you.

May her lakes and rivers bless you.

May the luck of the Irish enfold you.

May the blessings of Saint Patrick behold you.

May the cool rain

Quench your flowers' thirst

Renew your spirit,

And wash your troubles away.

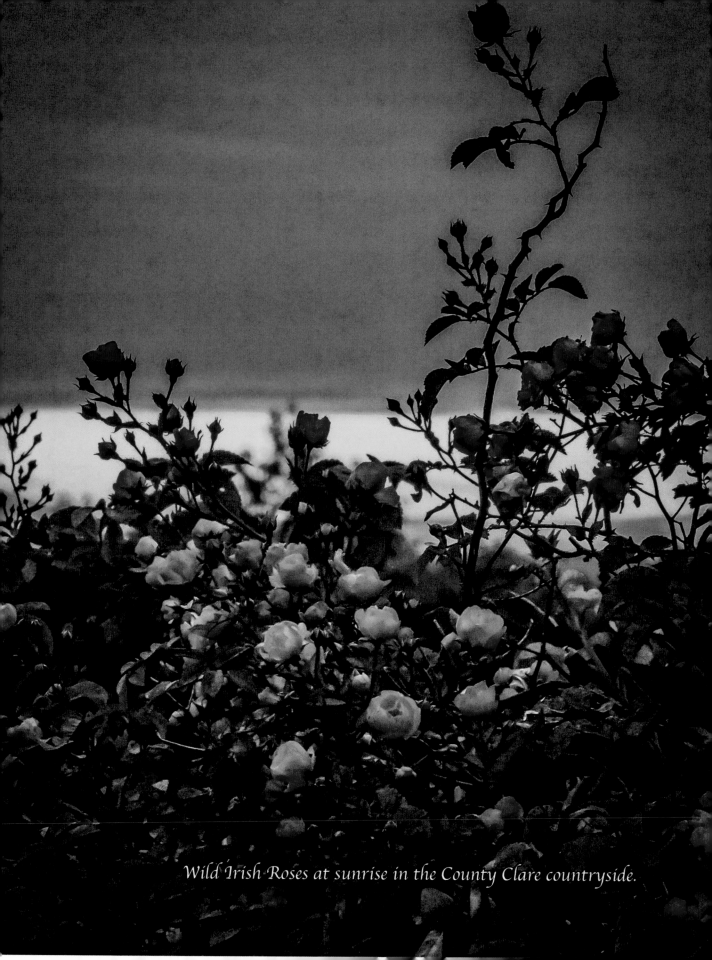

Wild Irish Roses at sunrise in the County Clare countryside.

May flowers always line your path,

And sunshine light your day.

May songbirds serenade you

Every step along the way.

May a rainbow run beside you

In a sky that's always blue.

And may happiness fill your heart each day

Your whole life through.

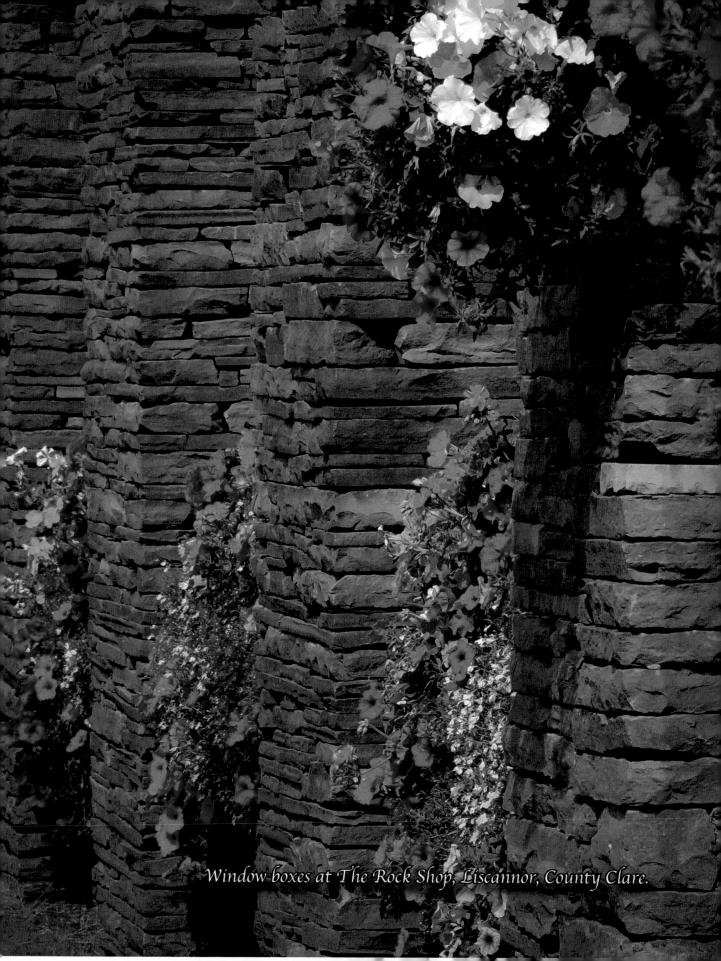

Window boxes at The Rock Shop, Liscannor, County Clare.

'Tis better to buy a small bouquet

And give to your friend this very day,

Than a bushel of roses white and red

To lay on his coffin after he's dead.

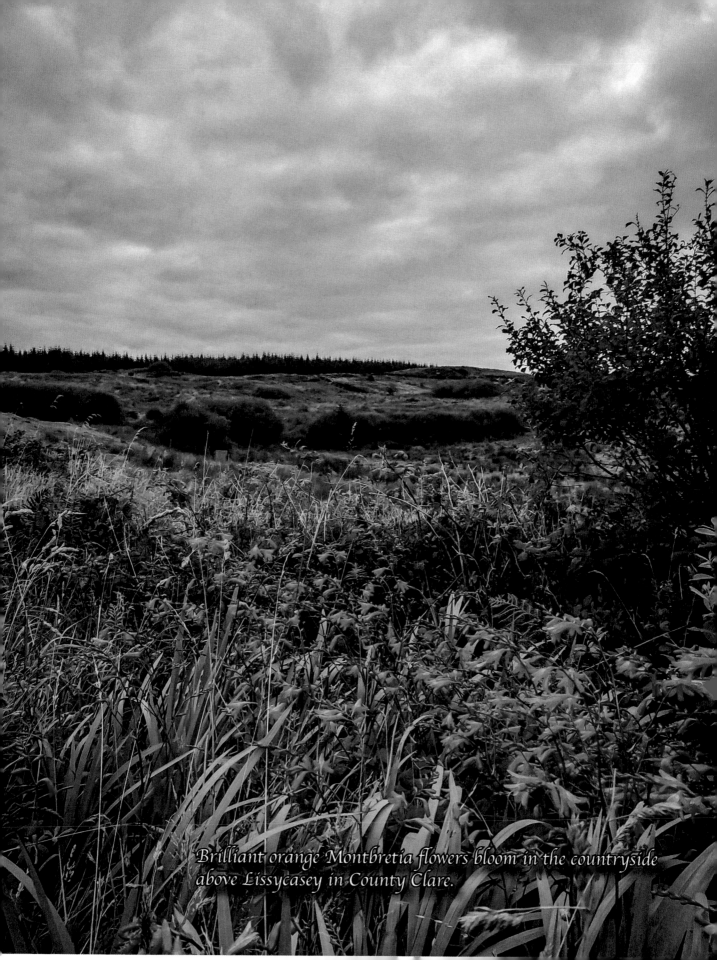

Brilliant orange Montbretia flowers bloom in the countryside above Lissycasey in County Clare.

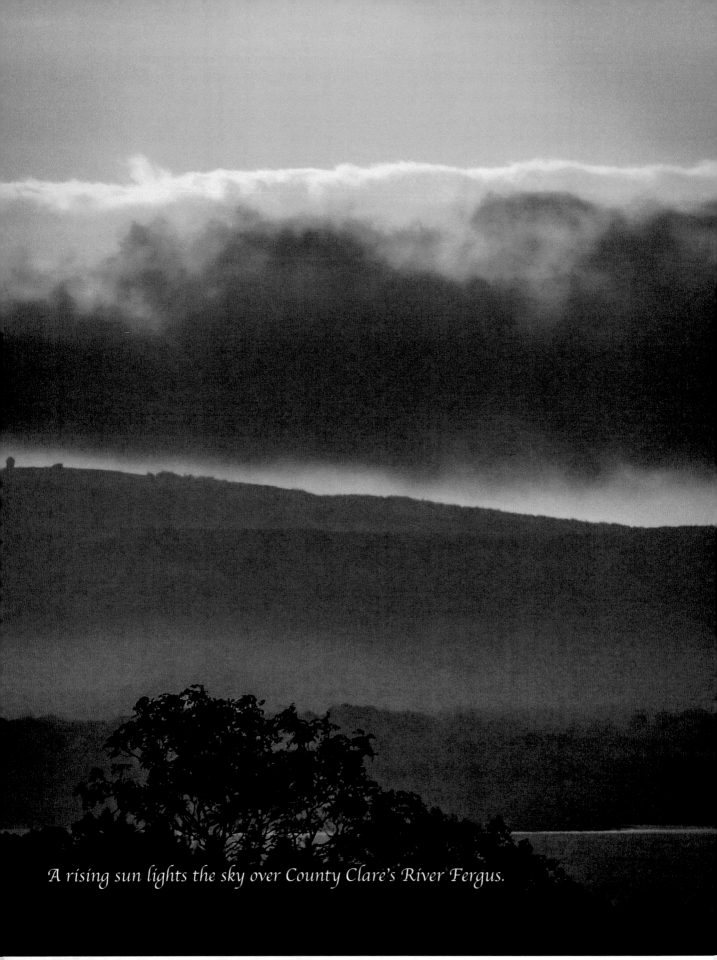

A rising sun lights the sky over County Clare's River Fergus.

May the saddest day

Of your future

Be no worse

Than the happiest day

Of your past.

Health and a long life to you.

Land without rent to you.

A child every year to you.

And if you can't go to heaven,

May you at least die in Ireland.

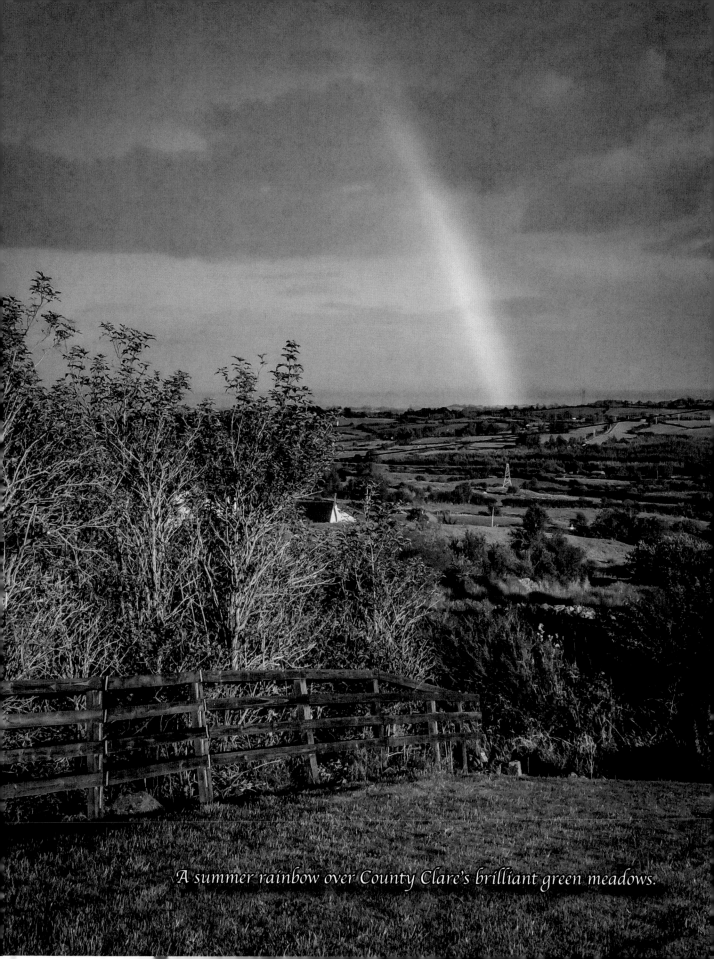

A summer rainbow over County Clare's brilliant green meadows.

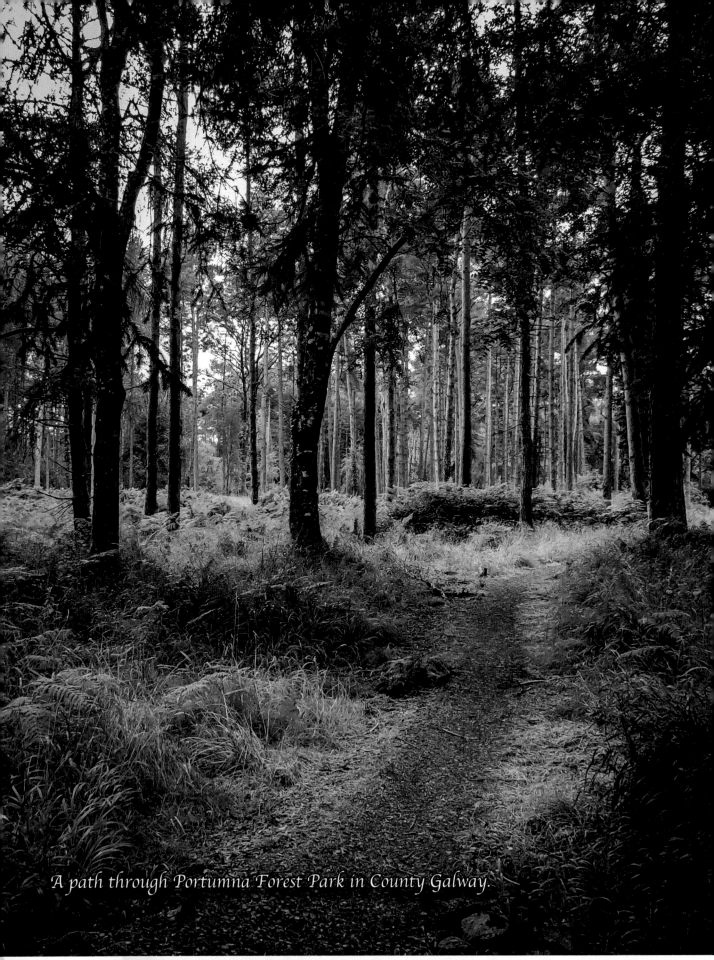

A path through Portumna Forest Park in County Galway.

An old Irish recipe for longevity:

Leave the table hungry.

Leave the bed sleepy.

Leave the pub thirsty.

Here's to health, peace and prosperity.

May the flower of love never be nipped

By the frost of disappointment,

Nor the shadow of grief fall

Among your family and friends.

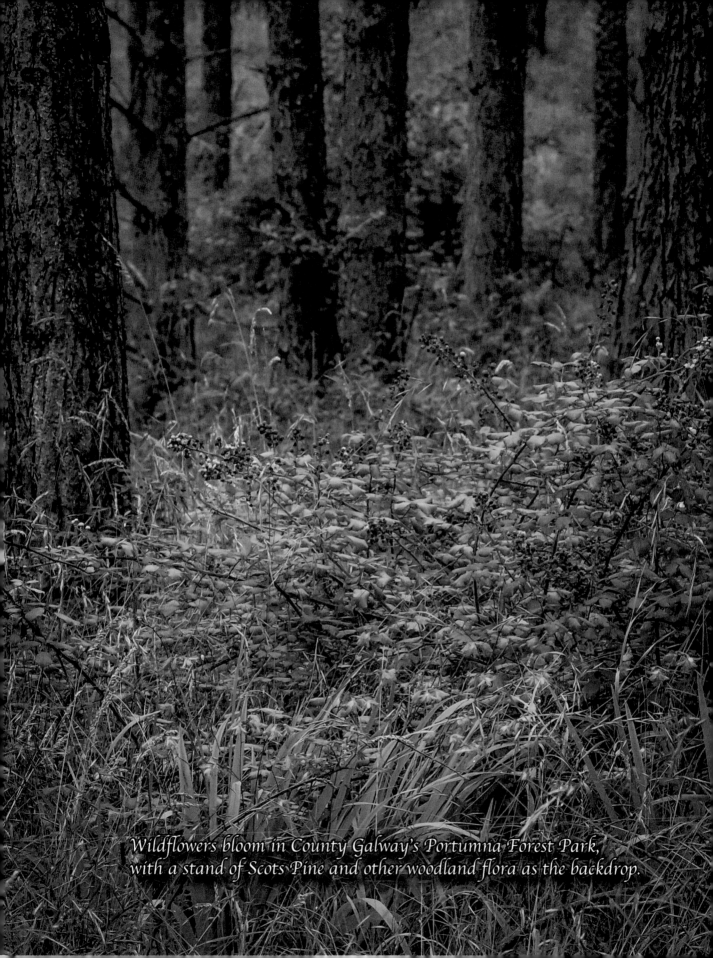

Wildflowers bloom in County Galway's Portumna Forest Park, with a stand of Scots Pine and other woodland flora as the backdrop.

May the blessings of each day

Be the blessings you need most.

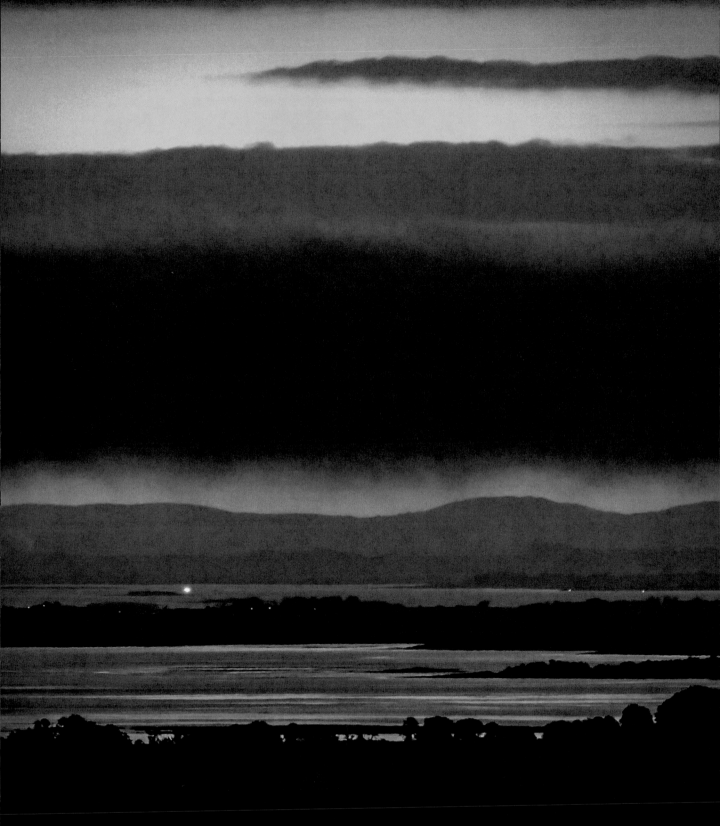

Dawn over County Clare's Fergus River, with the mighty Shannon River, County Limerick and the Galtee Mountains beyond.

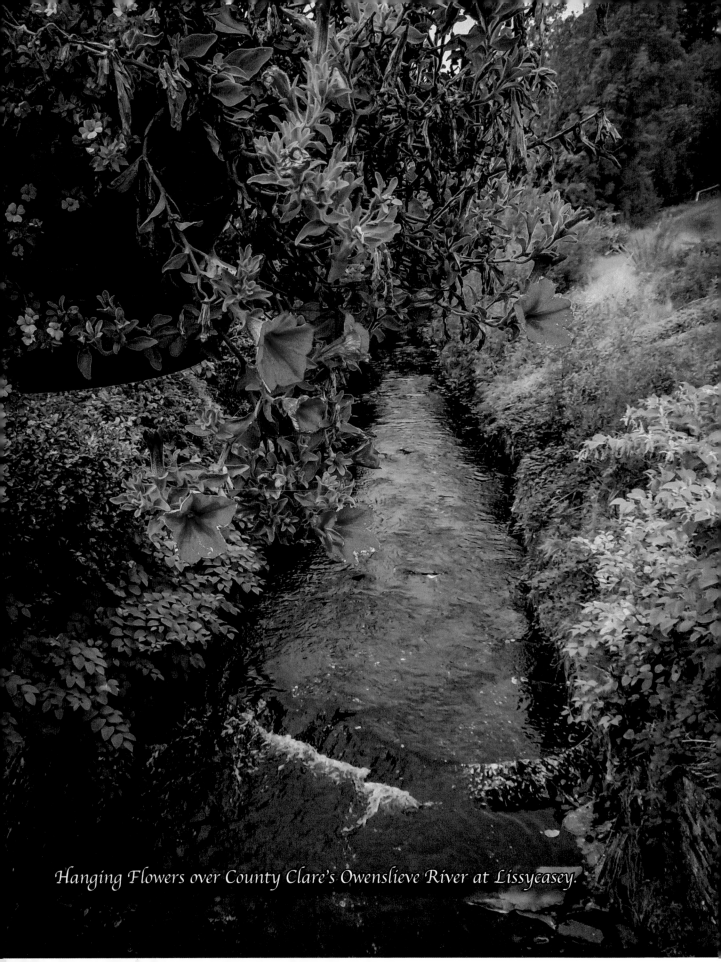

Hanging Flowers over County Clare's Owenslieve River at Lissycasey.

Always remember to forget

The friends that proved untrue.

But never forget to remember

Those that have stuck by you.

If you're enough lucky to be Irish...
You're lucky enough!

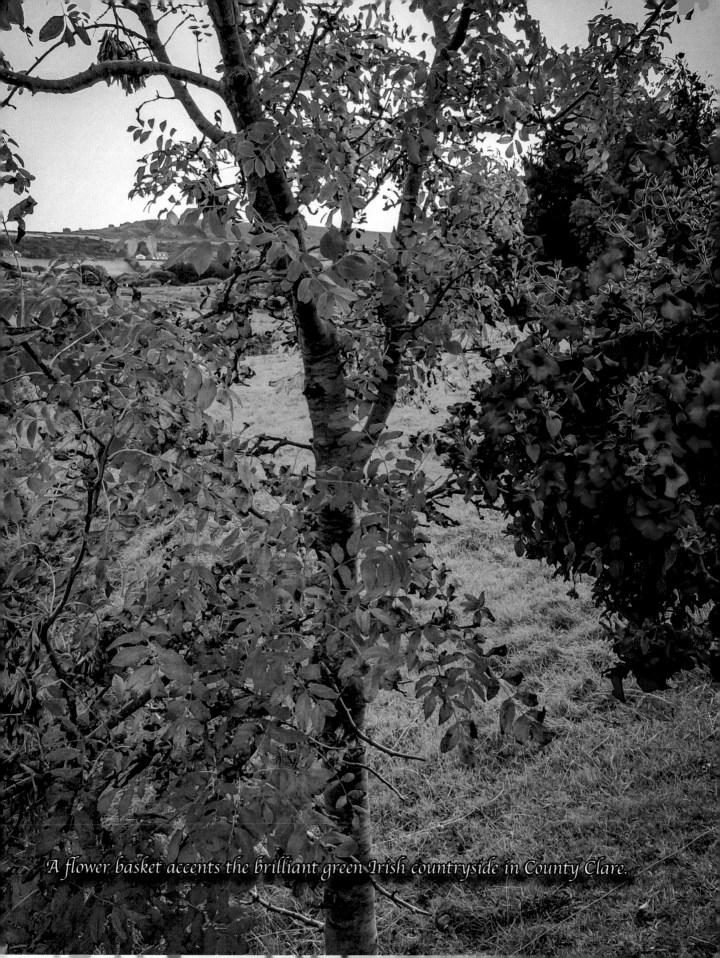

A flower basket accents the brilliant green Irish countryside in County Clare.

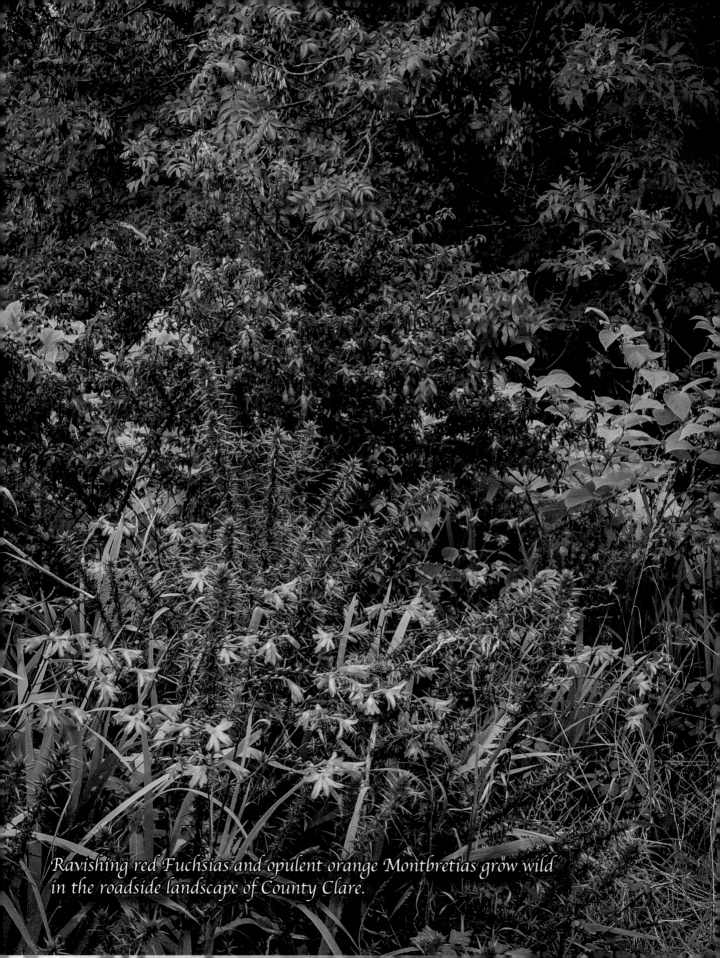

Ravishing red Fuchsias and opulent orange Montbretias grow wild in the roadside landscape of County Clare.

Always remember to forget

The troubles that passed away.

But never forget to remember

The blessings that come each day.

It's easy to be pleasant

When life flows by like a song.

But the person worth while is

The one who can smile

When everything goes dead wrong.

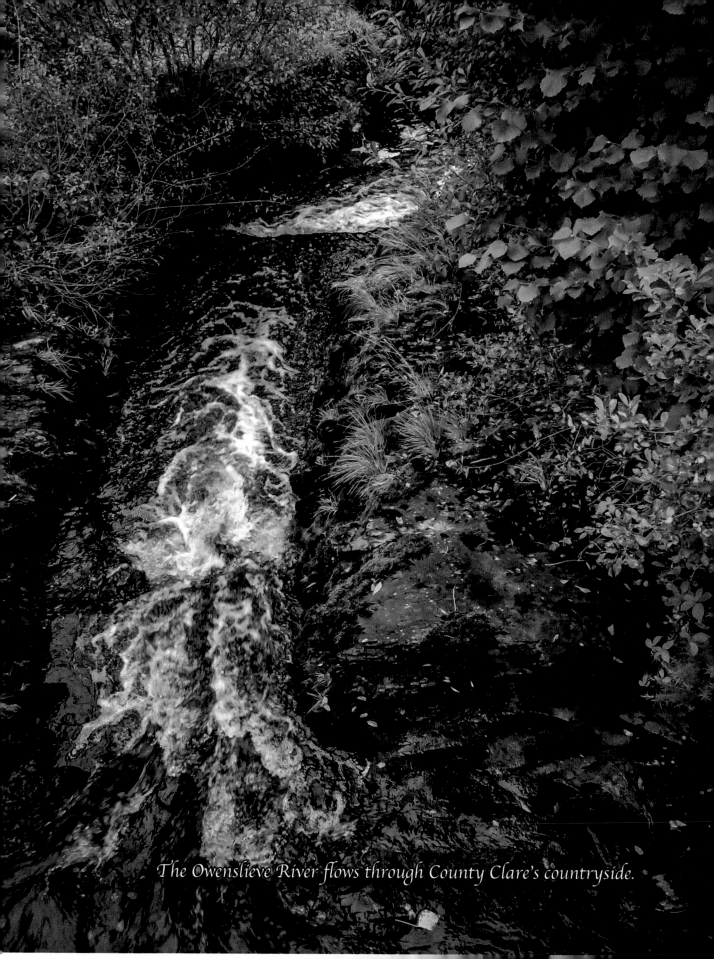

The Owenslieve River flows through County Clare's countryside.

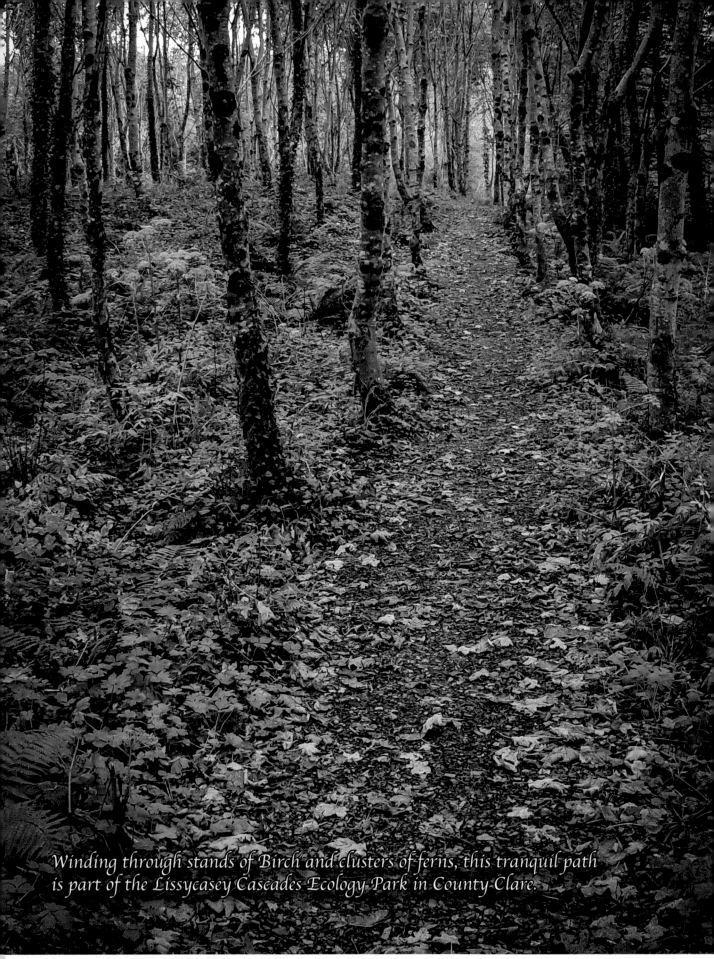

Winding through stands of Birch and clusters of ferns, this tranquil path
is part of the Lissycasey Cascades Ecology Park in County Clare.

For the test of the heart is trouble,

And it always comes with years,

And the smile that is worth

The praises of earth

Is the smile that shines

Through the tears.

May you live long,

Die happy,

And rate a mansion in heaven.

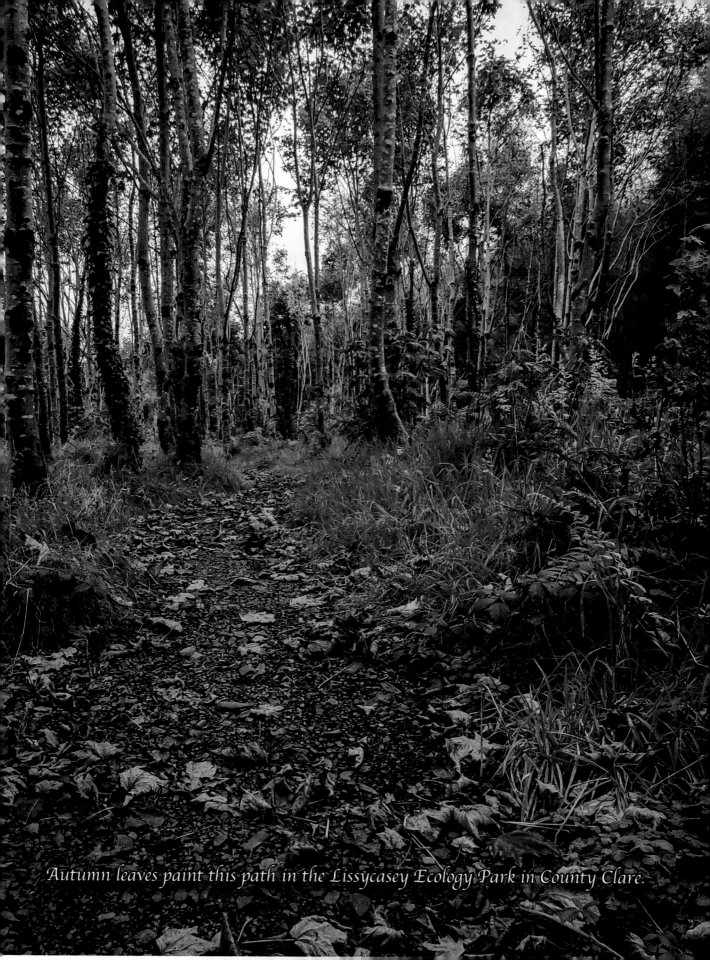

Autumn leaves paint this path in the Lissycasey Ecology Park in County Clare.

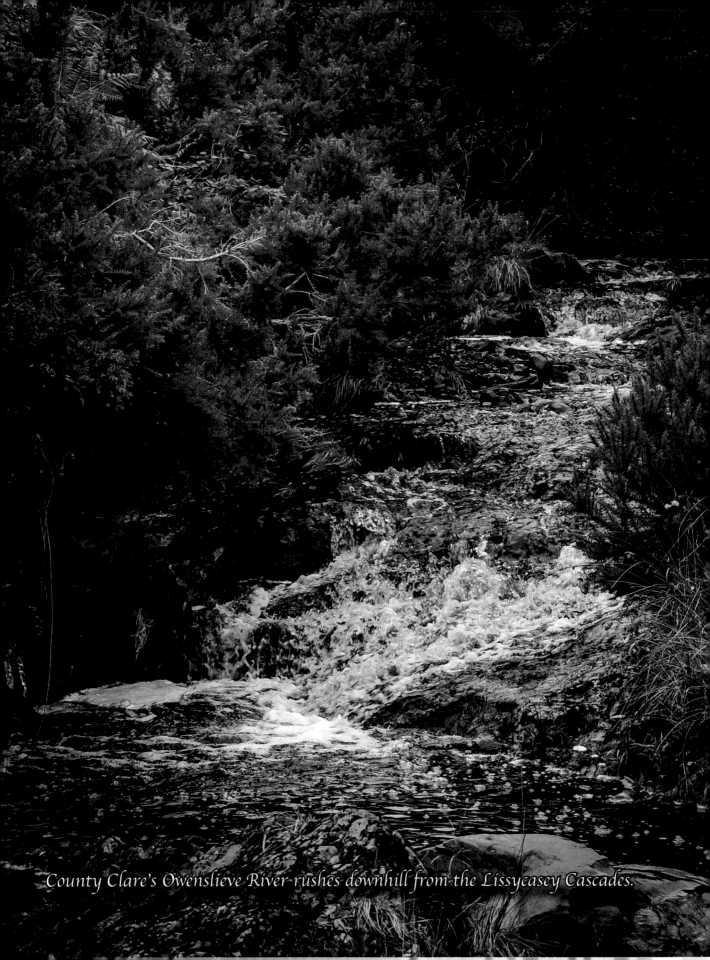

County Clare's Owenslieve River rushes downhill from the Lissycasey Cascades.

May your glass be ever full.

May the roof over your head

be always strong.

And may you be in heaven half an hour

before the devil knows you're dead.

We cannot share this sorrow

If we haven't grieved a while.

Nor can we feel another's joy

Until we've learned to smile.

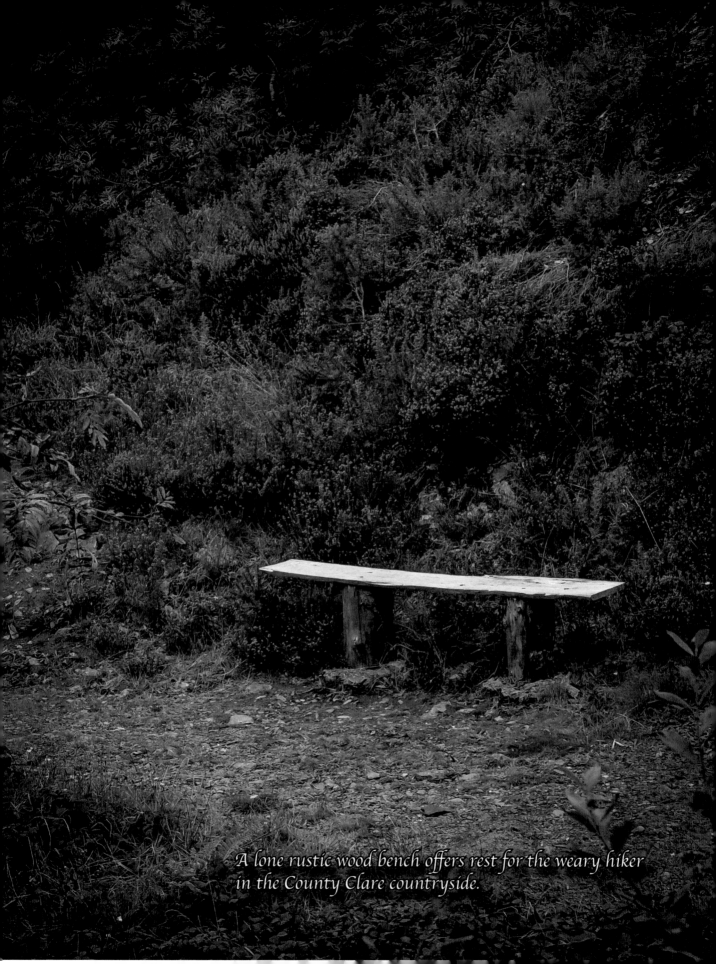

A lone rustic wood bench offers rest for the weary hiker in the County Clare countryside.

Always remember to forget
The things that made you sad,
But never forget to remember
The things that made you glad.

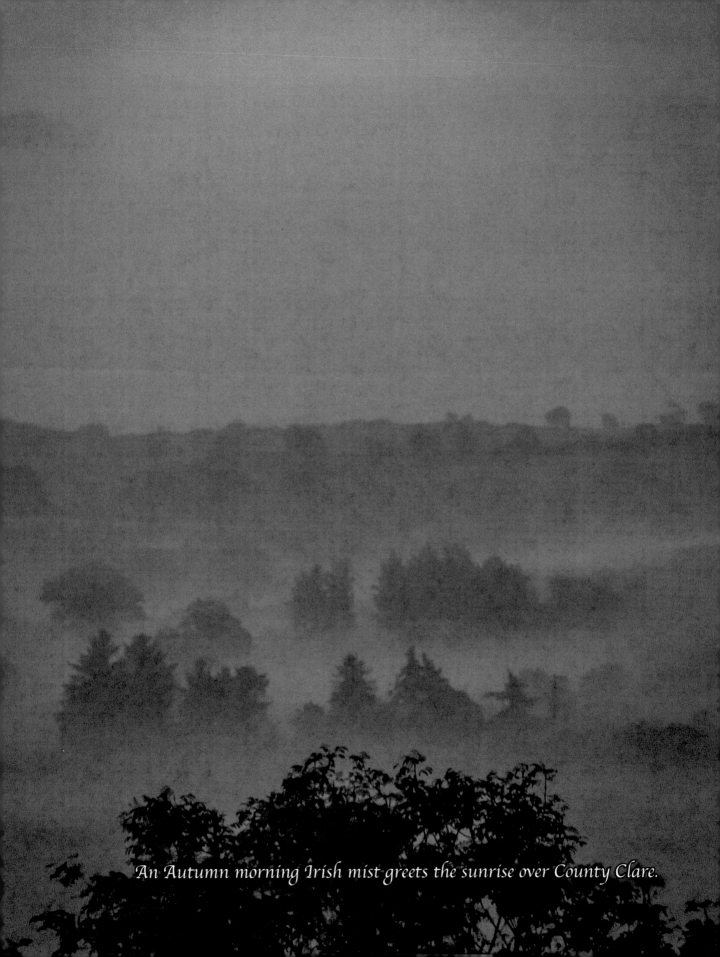

An Autumn morning Irish mist greets the sunrise over County Clare.

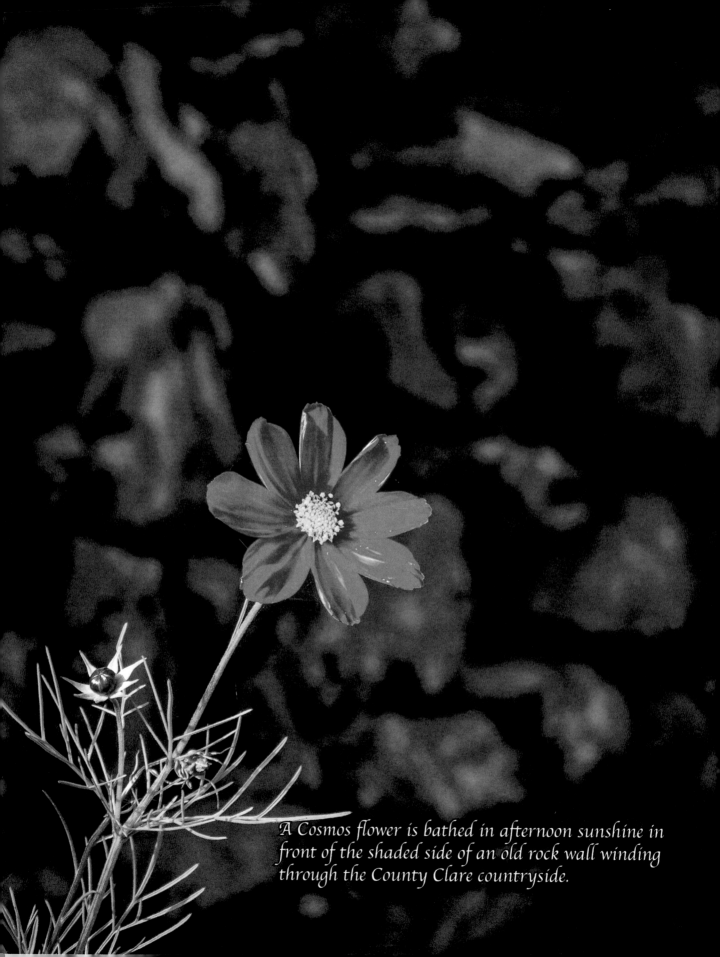

A Cosmos flower is bathed in afternoon sunshine in front of the shaded side of an old rock wall winding through the County Clare countryside.

May you live as long as you want,

And never want as long as you live.

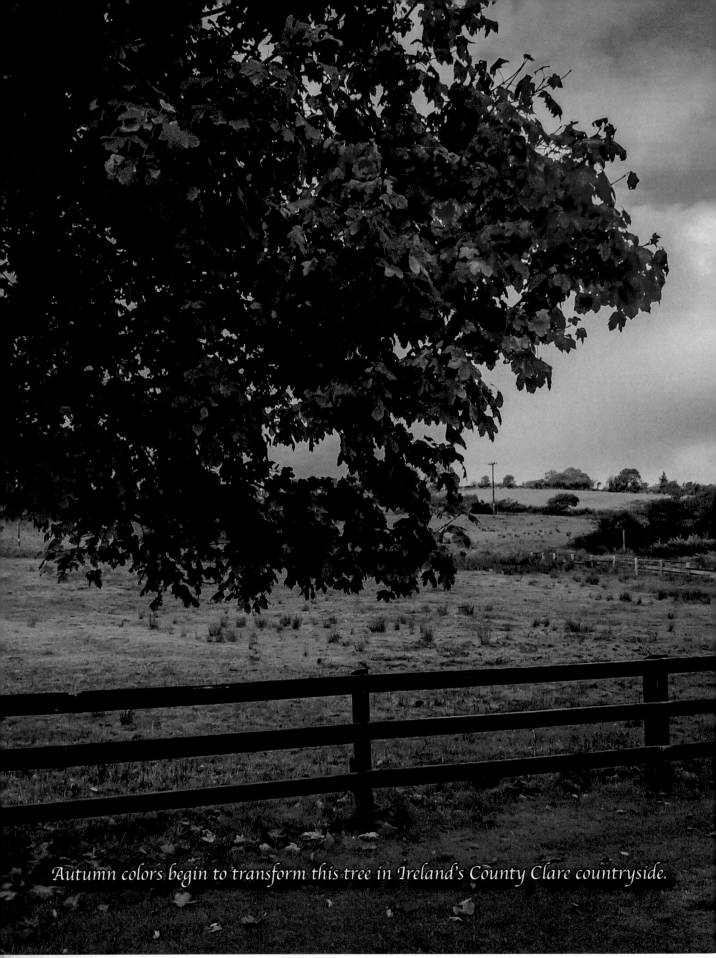

Autumn colors begin to transform this tree in Ireland's County Clare countryside.

May the joys of today

Be those of tomorrow.

The goblets of life

Hold no dregs of sorrow.

The moon rises as a sunset paints clouds over County Clare.

May you be poor in misfortune,

Rich in blessings,

Slow to make enemies,

And quick to make friends.

But rich or poor, quick or slow,

May you know nothing but happiness

From this day forward.

Remembering Irish Ancestors

Johanna Agnes Truett (née Cullinan), 1875-1937, *County Clare*

Patrick Henry Murphy, 1838-1913, *County Kilkenny*

Jane Cullinan (née Murphy), 1926-2011, *County Clare*

John Cullinan, 1926-1976, *County Clare*

Nora Murphy (née Markham), 1920-1957, *County Clare*

Paddy Murphy, 1910-1987, *County Clare*

Mary Murphy (née Roche), 1918-2006, *County Clare*

Thomas Murphy, 1925-2008, *County Clare*

Nora Cusack (née Madigan), 1943-2000, *County Clare*

Ellie Cusack (née McCarthy), 1914-1988, *County Clare*

Paddy Cusack, 1915-1989, *County Clare*

Angela McMahon (née McInerney), 1925-2012, *County Clare*

Mike McMahon, 1926-1990, *County Clare*

Noreen O'Connell (née Sheridan), 1923-2015, *County Clare*

Margaret Hurley (née Markham), 1841-1882, *County Clare*

John Hurley, 1839-1899, *County Clare*

Callaghan McCarthy, 1803-1877, *County Clare*

Bridget Melican (née Egan), 1843-1899, *County Clare*

Thomas Melican, 1827-1898, *County Clare*

Margaret Dolan (née Connor), 1847-1919, *County Roscommon*

Thomas Dolan, 1851-1932, *County Roscommon*

Acknowledgements
With Gratitude

For many personal reasons, this book has been a bit more challenging than most, and I have been blessed with the kindness of some very special people. THANK YOU so much for your encouragement and support!

Jennifer Nelson, *Florida (USA)*
Vivienne Nichols, *Tennessee (USA)*
Riki Lent, *New York (USA)*
Sandra Morrison, *California (USA)*
Pamela O'Dowd, *Texas (USA)*
Linda Chapman, *Oregon (USA)*
James Murphy, *Arizona (USA)*
Kathy Gregory, *Oregon (USA)*
Sue Ann Rivera, *New Jersey (USA)*
Pamela Hugaert, *Florida (USA)*
Francis & Helen Murphy, *County Clare (Ireland)*
John & Maureen Ginnane, *County Clare (Ireland)*
Alberto Truett, *Baja California Sur (Mexico)*
Sue McGovern Downward, *Baja California Sur (Mexico)*
Bridget O'Sullivan, *County Cork (Ireland)*
Pauline McDermott Smith, *County Cavan (Ireland)*
David & Elizabeth Odell, *Alaska (USA)*
Pat & Michele McMahon, *Illinois (USA)*
Michael & Margaret McMahon, *County Clare (Ireland)*
Robert & Mary McMahon, *County Clare (Ireland)*

Other Books by James A. Truett

Mystical Moods of Ireland - Vol. I:
Enchanted Celtic Skies

Mystical Moods of Ireland - Vol. II:
Enchanted Celtic Skies

Mystical Moods of Ireland - Vol. III:
Magical Irish Countryside

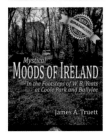

Mystical Moods of Ireland - Vol. IV:
In the Footsteps of W. B. Yeats at Coole Park and Ballylee

Available through Amazon.Com and major booksellers:
www.JamesTruettBooks.Com

*Follow James A. Truett's adventures
and get free previews of his books here:*
www.JamesATruett.Com/subscribe

About James A. Truett

Growing up in Alaska, near the quaint hamlet of Ester, near Fairbanks, James A. Truett developed an appreciation for nature as a child, exploring the majestic wilderness of his home state both on the ground and in the air.

He began his career as a journalist and photographer for the local newspaper at the age of 14, picked up his private pilot's license at the age of 17, and by the age of 19, he had moved to Seattle and joined The Associated Press, eventually becoming one of the youngest journalists in the world to be published in every major newspaper in the world.

Over the years, he developed an avid interest in sailing and traveled extensively by boat, auto and air in the U.S., Canada, Mexico, Central America, Ireland and the UK.

After tracing his ancestral roots back to Ireland and falling in love with the beauty of the Irish countryside, he settled in County Clare from where he manages his portfolio of art, photography and publishing projects.

Connect with James A. Truett on Social Media:
www.JamesATruett.Com/social

Irish Blessing

"May the embers from the open hearth
Warm your hands,
May the sun's rays from the Irish sky
Warm your face,
May the children's bright smiles
Warm your heart,
May the everlasting love I send you
Warm your soul."

JAMES A. TRUETT

Journalist • Author • Photographer • Artist

www.jamesatruett.com

Made in the USA
Monee, IL
17 October 2020